W9-CKB-731

WHERE'S THE FIRE?

American Firefighters in Picture Postcards circa 1910
by Geoffrey N. Stein

❦❦

Introduction by Janet Kimmerly

Postcards from the collection of
Dave and Christie Bowers

The Vestal Press, Ltd.
Vestal, New York

Library of Congress Cataloging-in-Publication Data

Stein, Geoffrey N.
 Where's the Fire?: American firefighters in picture postcards, circa 1910/by Geoffrey N. Stein.
 p. cm.
 Includes bibliographical references.
 ISBN 0-911572-91-0: $11.95
 1. Fire extinction - United States - History Pictorial works.
2. Postcards. I. Title.
TH9503.S83 1991
628.9'2'0973— dc20

 90 -26048
 CIP

Postcards from the collection of Dave and Christie Bowers
Cover design by Don Bell

Printed in the United States of America
First printing May 1992

INTRODUCTION

Every firefighter I have ever met (and I was born into a firefighting family) has had a deep and lasting interest in firefighting history. Just witness the number of firefighting museums throughout the country. Indeed, even individual firehouses are testimony to this desire to know what happened in the past: what kinds of apparatus were available and used? How were uniforms and gear designed? Who were the firefighters and what were their backgrounds?

Where's the Fire? is yet another example of our fascination with the recorded past. This is truly a ride down memory lane with the fire service.

There is something here for everyone—the enthusiast who has an interest in the fire service as well as the firefighter who loves the historical aspects of his chosen field. All geographical regions are well represented with apparatus and firehouses from 34 states plus Washington, D.C., included.

The cards whet one's appetite for even more information than that provided. In fact, the series of cards focusing on Providence, Rhode Island (numbers 170–178), provide the kind of information (identification of truck, date of service, equipment, and company manning) that I wish had accompanied all of the postcards. (Cards 123, 124, and 241 also provide the kind of information sought.)

With a number of states represented, it is interesting to note the varying architectural styles of different regions. No two are alike; their shapes and sizes offer all of the variety one could imagine. In fact, in some areas, the firehouse had a dual role—it served as the city hall, too.

Some of the cards are interesting for the activities recorded on them. Today's fire services often sponsor softball, bowling, or drill teams. Back in 1909, the Denison, Iowa, Fire Department fielded a track team, something I found rather unusual. Card 148 captures a fire drill taking place in Lake Placid, New York, in the early 1900's.

The choice of cards showing the Fire Department of the City of New York (FDNY) shows diversity. This fire department, by which most others are judged, is shown in simulated or painted action images (Cards 151–158), but best of all is the card showing the members practicing their jumping (Card 154).

Although no longer the most popular trucks, American LaFrance apparatus had a tremendous following for a good many years. Their fans will especially appreciate the card showing the American LaFrance factory in Elmira, New York (Card 141).

Most readers will enjoy the series of cards depicting "the alarm," "turn out," "down the pole," "hook-up," "ready," "start," "on the way," and "fighting the fire" (Cards 31–38). This is firefighting in Washington, D. C., the way it used to be.

Except in large cities (New York City, Washington, D. C., Detroit, etc.), most of these firefighters were volunteers. According to Vincent P. McNally, Ph.D., volunteers in the largest cities were replaced by paid and paid on-call firefighters between 1871 and 1877 (see "History of the Volunteers," *Firehouse*, May and June 1986).

The bulk of apparatus showcased in this postcard album is from 1905–1918 with most of it built in the late 1890's and early 1900's. It is interesting to see the evolution of these vehicles and the beginning of motorized equipment. While it was a beginning, it was also an end for the horse-drawn era, and horses gradually disappeared from the scene.

By 1913, most apparatus manufacturers had gone from hard rubber to pneumatic tires. Other improvements included electric headlights and starters, and four- or six-cylinder engines.

Steam engines were also fading away in favor of motor-driven pumps. (For an authoritative history about the motorization of the fire service, see "Horseless Carriages" by Richard M. Adelman in the November, 1987, and January, 1988, issues of *Firehouse*.)

(CONTINUATION OF INTRODUCTION)

Where's the Fire? is a trip back into time "when fires were fires and men were men." It is a worthy addition to the bookshelf of any firefighter interested in the history of his profession and any buff who is enthralled with the fire service.

JANET KIMMERLY

Janet Kimmerly is the Executive Editor of Firehouse Magazine, the world's leading fire service publication. She is a five-year member of Protection Engine Company #1 of the Port Washington, New York (volunteer) Fire Department (PWFD). She is the Recording Secretary of the PWFD and, as such, is a member of the Board of Directors.

PREFACE

Most of the postcards in this volume date from the late 1900's and early 1910's when a postcard boom enveloped the United States. Among the many subjects deemed worthy of documentation by card publishers were fire departments in both big cities and small towns.

While the number of fire postcards that have survived is considerable, the reader of this album will note that a large percentage of those images have a similar format no matter where the pictures were made: a glance at a few pages of this book shows many photos of men and apparatus standing in front of fire stations. It is not difficult to figure out why these portraits predominate. It was easier, certainly, to photograph a company outside of a building than inside it. And exciting fire scenes were thankfully rare.

The fire departments posing for their pictures naturally brought out their most significant apparatus. Consequently, the postcards show what was vital and innovative in firefighting of the 1910 period. For example, a great number of steam engines are present in these photos because steamers were the standard form of pumping engine. Looking back, we now know that most of those engines would be gone within a decade or so.

Horse-drawn apparatus are present in a majority of these pictures, but we see the first stages of motorization represented as well. In many departments, automobiles had already displaced officers' buggies. Combination motor chemical-and-hose cars are depicted in these cards, too. And a few tractor-drawn aerials and water towers are present.

Chemical apparatus were valued for their rapid response to small blazes in the 1910 era, so they appear on many cards. As with steam engines, most chemical equipment would be gone in a decade or so.

Happily, there *are* firefighting scenes in this collection. And there are views of the firemen inside the station as well as outside drilling and exercising horses.

Perhaps some readers will be surprised by the postcard photos of very small fire departments. The explanation lies in the operation of the postcard publishers. Large concerns often sent their photographers out over a broad geographical area to snap schools, churches, shops, and any other structures that might have potential resale as a postcard image at the local store. Naturally, firehouses with their memberships and equipment in front of them were ideal subjects for the itinerant cameramen. And if, for some reason, the major publishers missed a particular fire department, it was easy enough for a local photographer cum publisher to take the picture and print a number of copies on postcard stock for distribution.

The arrangement of the postcards in this album is alphabetical by state. Within states, the breakdown is alphabetical by place name. Whether the reader starts at the beginning or with the fire department of a particular place, the images of nearly a century ago remain informative and entertaining.

Geoffrey N. Stein

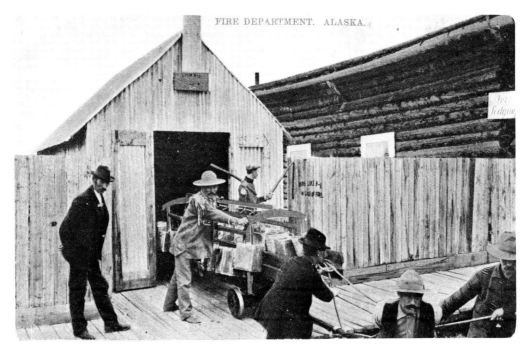

FIRE DEPARTMENT. ALASKA.

1. ALASKA. (No geographic subdivision.) Here was a frontier fire company with the most elementary equipment. The apparatus resembled a hand engine; but apparently, it was simply a bucket wagon hand-drawn by rope and pole. The instructions on the fence above the board sidewalk were probably for a gong and read, "Ring Like H--- In Case of Fire."

2. BISBEE, ARIZONA. Bisbee's firemen probably were testing the pressure in a piped water system in this picture. Note that the hose ended at a standpipe, an arrangement possible only where significant frost was not a problem (or perhaps there was a hydrant hidden by the man in dress uniform). The wagon, equipped with a ground ladder and extinguisher, served principally as a hose carrier.

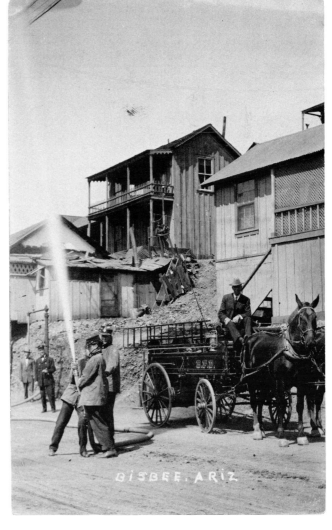

BISBEE. ARIZ

3. DOUGLAS, ARIZONA. Competition between companies in firefighting skills continues almost a century after the photo for this postcard was taken. Racing with their hose cart was likely the prime event contested by the Douglas firemen. The American Fire Engine Company of Seneca Falls, New York, and Cincinnati,

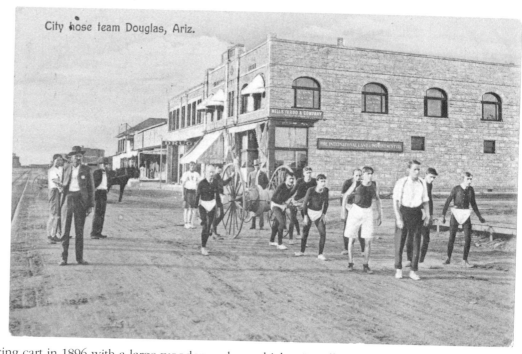

Ohio, introduced a racing cart in 1896 with a large wooden reel on which a "small amount of hose used in coupling contests can be wound readily." *Ref.: Fire and Water.* July 4, 1896.

4. ROGERS, ARKANSAS. The American-LaFrance Fire Engine Company of Elmira, New York, sold this Type 20 combination chemical-and-hose car in 1915. A 2½-inch water delivery hose was stored in the bed; chemical hose of a smaller diameter lay in the basket above. The chemical tank was the nickel-plated cylinder under the seat. Rogers bought a second American-LaFrance vehicle—a Type 40 pump-and-hose car—in 1918. *Ref.:* American-LaFrance Fire Engine Company, Inc. *Sales List to May 31, 1927.*

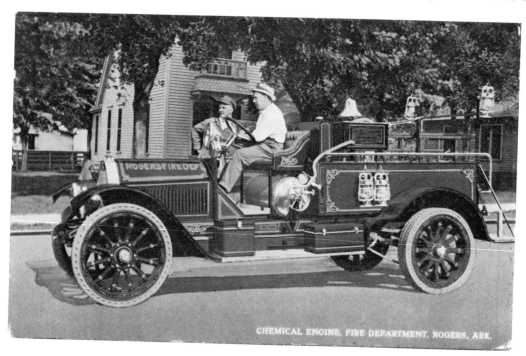

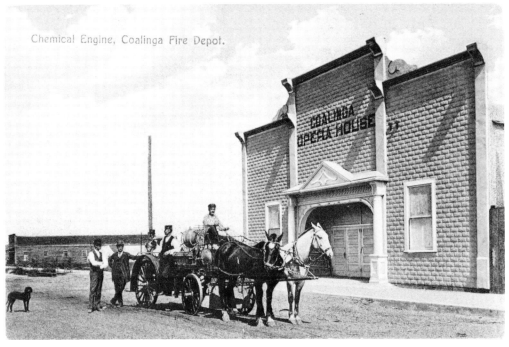

Chemical Engine, Coalinga Fire Depot.

5. COALINGA, CALIFORNIA.
In 1910, Coalinga was Fresno County's second largest city. Its 5,500 residents owed their prosperity to oil wells. Chief of the volunteer fire department was Oscar J. Macy, whose paid job was foreman of the Pleasant Valley Water Company. This photo actually shows a combination hose-wagon-and-chemical-engine. *Ref.: Fresno, Coalinga and Fresno County Directory:* 1910.

6. HOLTVILLE, CALIFORNIA. Holtville's circa 1920 Reo was an extremely well-equipped fire engine. A pump under its seat was supplemented by two chemical tanks behind the driver. Hard suction hose was mounted on the rear fender, chemical hose on the reel, and pump delivery hose in the bed. Other equipment included a play pipe and fire extinguisher on the rear step, a bell behind the chemical hose, a ladder on the left side of the body, and a searchlight on the fire wall just above the characteristic Reo fuel tank.

The driver's old style of helmet is notable for its high crown. *Ref.:* West, Peter D. *The History of the Buffalo Fire Appliance Company* (identifies Reo chassis, which was sold by the Buffalo firm and other companies).

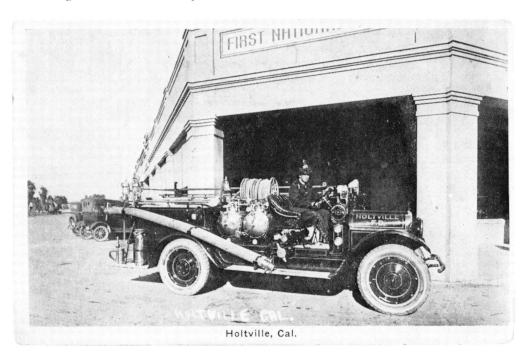

Holtville, Cal.

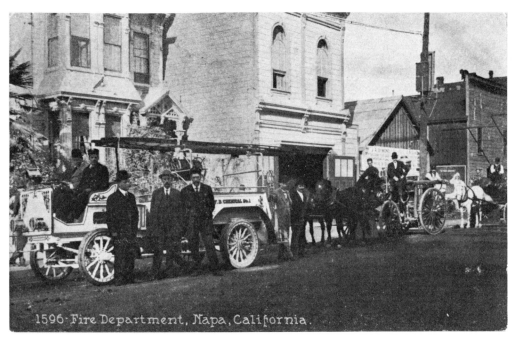

1596 Fire Department, Napa, California.

7. NAPA, CALIFORNIA.

In 1910, here was a fire department in transition. The Seagrave chemical engine on the left introduced motor apparatus to Napa. The horse-drawn steam engine and tender wagon on the right were soon retired in favor of other gasoline-powered vehicles.

Ironically, the evolution in firefighting apparatus quickly left the Seagrave obsolete. Hard rubber tires and acetylene lighting were short-lived equipment, and chemical apparatus were soon replaced by booster lines fitted to self-propelled pumpers. *Ref.*: McCall, Walter P. *American Fire Engines Since 1900.* Glen Ellyn, Illinois: 1976.

8. REDDING, CALIFORNIA. It appears that the Redding Fire Department, circa 1909, occupied the building at the right of this postcard view—note the bell on its roof and the ladder inside the doorway. The Seagrave chemical engine was fitted with two tanks that, in theory, allowed the second one to be used while the first was recharged. The engine also had double hard-rubber tires in the rear, acetylene headlamps, ground ladders on a roof rack, and very handsome decoration. That is a palm tree behind the apparatus.

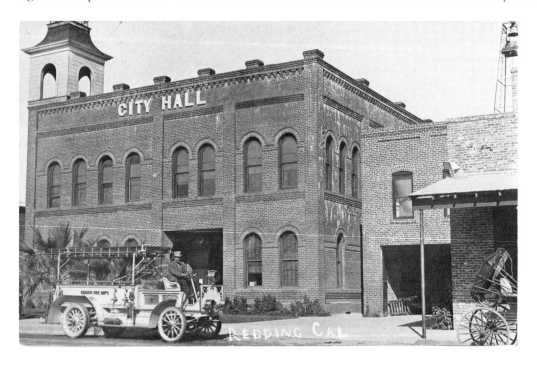

REDDING CAL

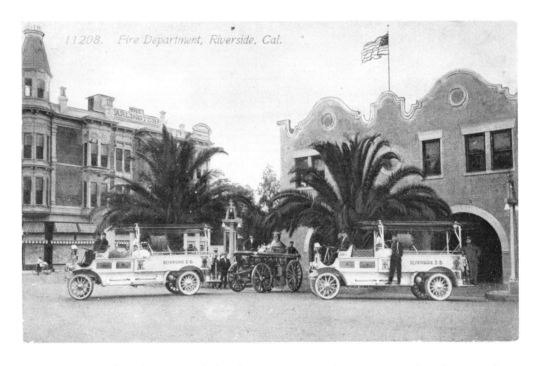

9. RIVERSIDE, CALIFORNIA.

At the beginning of the 1910's, Riverside operated a hose wagon and a ladder truck in addition to the steam engine. All vehicles likely were horse-drawn, then two self-propelled Seagrave chemical engines joined the equipment roster. These two chemical engines, characteristically white, provided a sharp contrast to the steamer in this photo. *Refs.:* Riverside city directories: 1910, 1912, and 1921.

10. SAN DIEGO, CALIFORNIA. The small-scale 1915 World's Fair that was called the Panama-California Exposition featured "Spanish Colonial" architecture for its temporary buildings. Undoubtedly, the fire apparatus was a more permanent fixture in the city.

The rig on the left is fitted with a chemical tank. The engine in the center has ground ladders in an overhead rack. And the straight ladder truck is fitted with tiller steering to compensate for the very long wheelbase. *Ref.:* Winslow, C. M. *The Architecture and Gardens of the San Diego Exposition.* 1916.

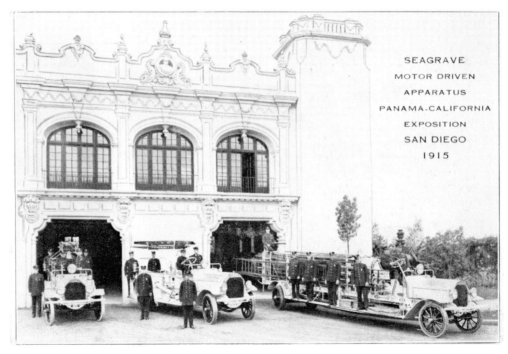

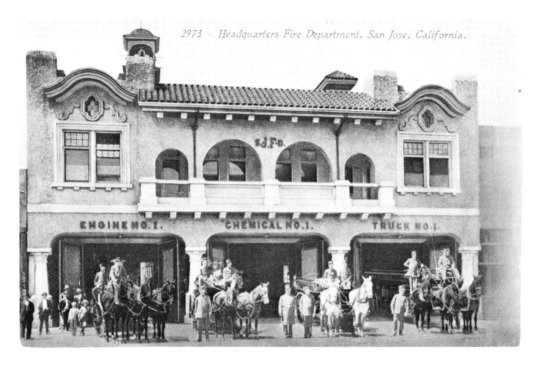

2973 - Headquarters Fire Department, San Jose, California.

11. SAN JOSE, CALIFORNIA. In the 1900's, from whence this postcard likely dates, the requisite small boys posed with San Jose's new headquarters building, a steamer, chemical engine, hose wagon, and ladder truck. A few years before, in 1899, City Hall served as fire headquarters while three steamer, three hose, and several chemical-and-ladder companies comprised the city's fire force. By 1925, the by-then-paid department operated ten companies in eight stations. *Refs.:* Nailen, R. L. *Guardians of the Garden City.* San Jose: 1972. San Jose city directory: 1899.

12. SAN PEDRO, CALIFORNIA. In 1909, the city of Los Angeles annexed San Pedro, a harbor community on the Pacific. Here we see what appears to be a chemical engine of that period (the image's small size makes identification difficult). In 1923, Engine 36 of the Los Angeles Fire Department Harbor Division was assigned to City Hall with Engine 40 and Fireboat 1 nearby. *Refs.: Encyclopaedia Britannica.* Los Angeles city directory: 1923.

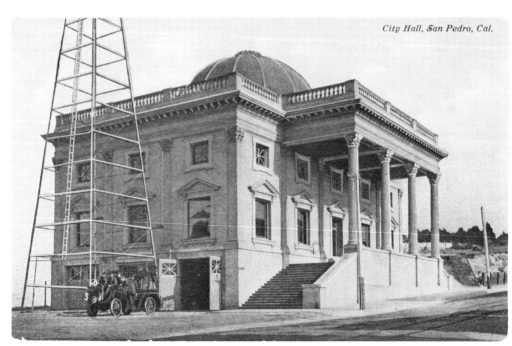

City Hall, San Pedro, Cal.

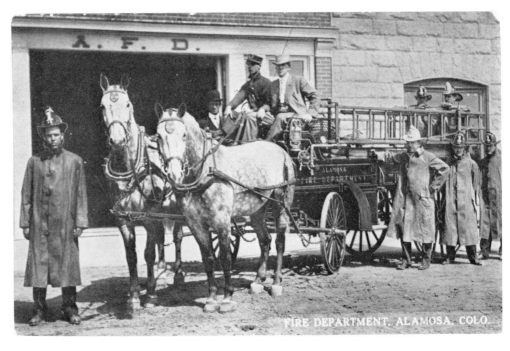

FIRE DEPARTMENT. ALAMOSA, COLO.

13. ALAMOSA, COLORADO.

If this was Alamosa's sole apparatus (and entire membership), the Colorado community had a versatile machine for the 1910 period. Under the seat is a chemical tank that delivered pressurized water through the small-diameter hose coiled behind the driver. In the wagon is a larger-diameter hose suitable for direct attachment to a hydrant. On the sides of the wagon are ground ladders that give firefighters access to upper stories.

14. CRIPPLE CREEK, COLORADO. The gold mining community of Cripple Creek suffered two serious fires in 1896. The first one burned eight square blocks. Eight days later, another conflagration leveled forty acres. The date on the cornice of this card indicates that City Hall and the fire station were spared. *Ref.*: Lee, Mabel B. *Cripple Creek Days*. New York: 1958.

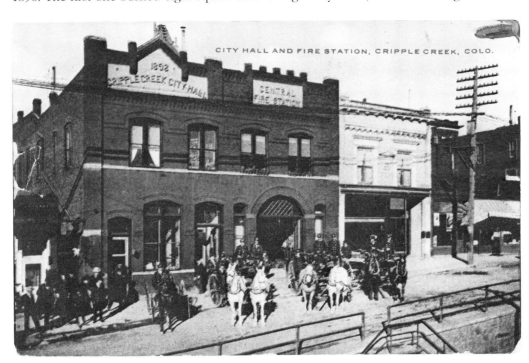

CITY HALL AND FIRE STATION, CRIPPLE CREEK, COLO.

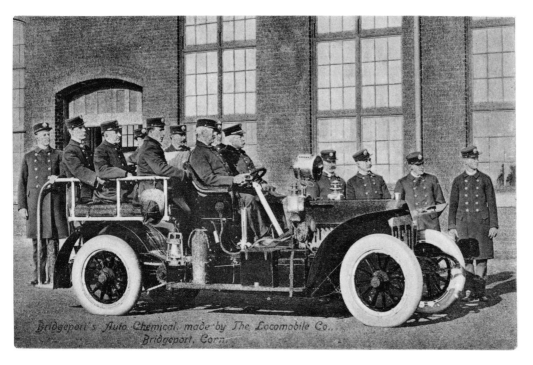

The Locomobile Company of America was a Bridgeport firm that built automobiles. A Locomobile chassis served as the basis for Auto Chemical Number One. In 1911, Number One, at 268 Middle Street, was under the direction of Captain Charles W. Holden with John T. O'Connor and James J. Monahan as drivers. When the photo for this card was taken in about 1907, however, Chief Engineer and Fire Marshall Edward Mooney himself was probably in the front passenger seat. Note the flattened rear tire from the weight of the crew. *Refs.*: Bridgeport city directories: 1908 and 1911. Danenberg, Elsie N. *The Story of Bridgeport*. Bridgeport: 1936. George C. Waldo, Jr. *History of Bridgeport and Vicinity*. New York: 1907.

16 –18. HARTFORD, CONNECTICUT. The largest and probably most famous engine of its day was the 1,350-gallon-per-minute, self-propelled Amoskeag double extra first-size steamer seen here in three views. The portrait of the stationary machine, Card 16, plainly shows the chain drive to the rear wheels as well as the traction spikes on the tires.

The artistic presentation of the engine in relief, Card 17, is notable for its similarity to the photographic representation; it is obvious that the latter was a model for the former.

The action picture, Card 18, shows the Amoskeag at its practical speed of ten miles per hour. Tillerman James Magonigal of Blake Steam Propelling Fire Engine Company Number Three earned $900 in 1901. His colleague, Charles H. Frye, collected the same salary to drive the hose wagon.

A second self-propelled steamer was operated by Hartford's Annihilator Engine Company Number Four. *Refs.*: *Amoskeag Steam Fire Engines*. Philadelphia, 1895; rpt. Manchester: 1974. Hartford city directory: 1901. King, William T. *History of the American Steam Fire Engine*. 1895; rpt. Chicago: 1960.

16.

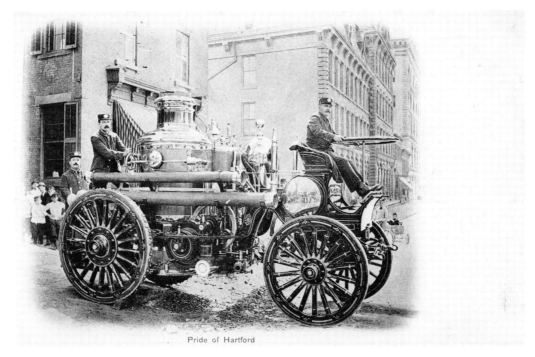

Pride of Hartford

17.

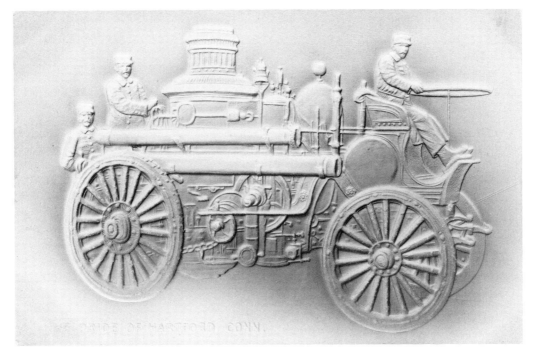

18.

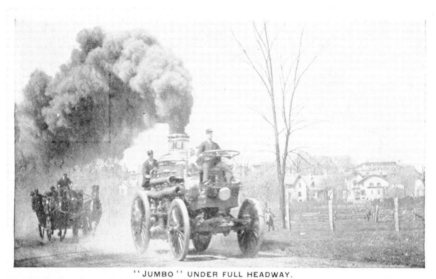

''JUMBO'' UNDER FULL HEADWAY.

Steam Fire Engine No. 3 (self-propeller), Hartford, Conn.

19. HARTFORD, CONNECTICUT. In mid-1910, Engine Fourteen operated from a station at 35 Bluehills Avenue. An engine, hose wagon, and ladder truck comprised the apparatus roster with the truck probably carrying the life net.

Personnel included: George Estlow, Captain; Frank Claffey, Lieutenant; James F. Cummings, Engineer; John J. Walsh, Stoker; John F. Dungan, Engine Driver; William C. Case, Hose Driver; Clarence A. Andrews, Truck Driver; David F. McSweegan, Hoseman; James E. Trerice, Hoseman; Nathan F. Levee, Hoseman; Benjamin D. Barley, Ladderman; James E. Blanchfield, Ladderman; George L. Brouillard, Ladderman. *Refs.:* Hartford city directories: 1908 and 1910.

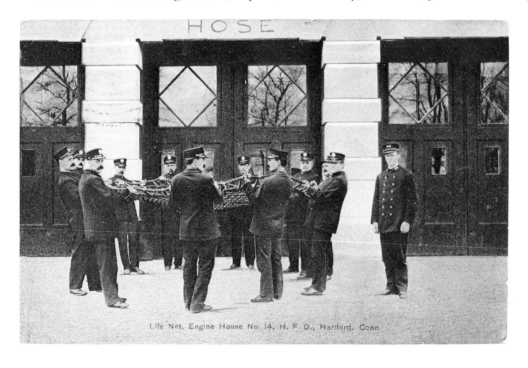

Life Net, Engine House No. 14, H. F. D., Hartford, Conn.

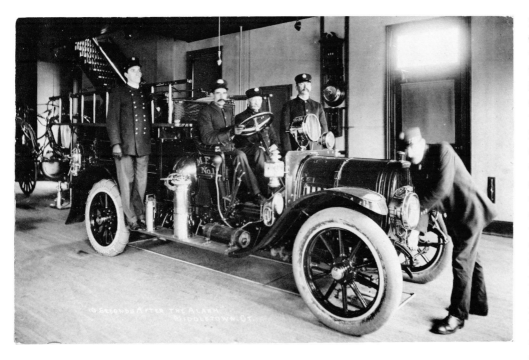

20. MIDDLETOWN, CONNECTICUT. "Ten Seconds After the Alarm" reads the faint caption for this card. In the early 1910's, Middletown's fire department operated three hose companies as well as a hook-and-ladder company with a combination of volunteer and paid personnel. O. V. Coffin Hose Company Number One took obvious pride in its combination hose and chemical engine built on, apparently, a Pope-Hartford chassis. Foreman of the company in the 1910–1912 period was Edward Hills. Note the drip pan under the vehicle, the acetylene lamps, the unattended horse-drawn apparatus in the back, and the man at the right operating the engine starting crank. *Refs.*: Middletown city directories: 1910, 1912, and 1914.

21. NEW HAVEN, CONNECTICUT. Engine Seven received its new first-size Clapp and Jones steamer in May, 1902. The engine may well have been one of the last steamers built with the Clapp and Jones name; the parent International Fire Engine Company had already introduced its Metropolitan engine, which replaced several venerable lines. As an independent firm, Clapp and Jones dated from 1866 when Mirtillow Clapp and Edward Jones began production of steam engines in Hudson, New York. *Refs.*: Peckham, John M. *American LaFrance: Its Predecessor Companies & Corporate Name Changes.* Troy, NY: 1982. Walker, Harold S. *Partial List of Clapp and Jones Steam Fire Engines.* Unpublished: 1974.

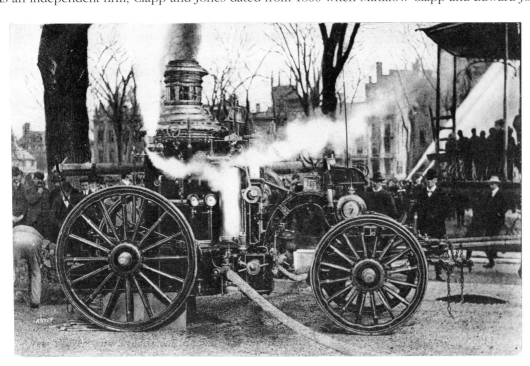

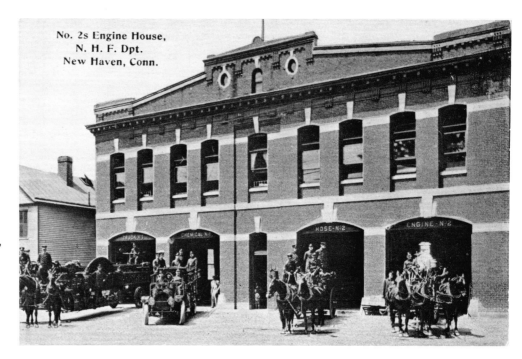

22.–23. NEW HAVEN, CONNECTICUT.

Engine Two's motorization followed the pattern of many departments with the chemical company getting the first gasoline-fueled vehicle. Card 22 shows the Connecticut-built Pope-Hartford chemical (second from left) while Card 23 is a close-up of the same rig with its crew of eight men at the same location—130 Olive Street. In 1911, other apparatus at Engine Two included a second-size Clapp and Jones steamer of 1897 and a hose wagon operated by a captain, lieutenant, and ten firemen. Hook and Ladder Number One had a complement of eighteen men. *Refs.:* New Haven city directory: 1911. Walker, Harold S. *Partial List of Clapp and Jones Steam Fire Engines.* Unpublished: 1974.

23.

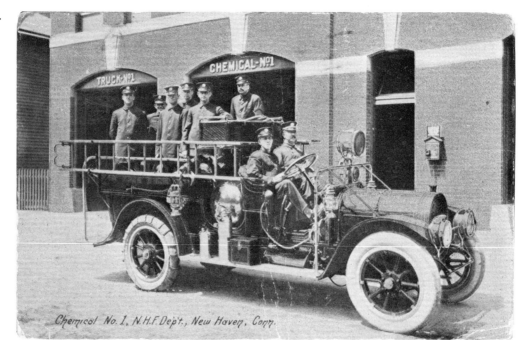

24. STAMFORD, CONNECTICUT.

Stamford acquired a steam fire engine in 1883 after fire destroyed the Presbyterian church the year before. A paid crew took charge of the horses and apparatus while volunteers gathered at fires and received "moderate monthly stipends" (Sherwood). Headquarters for a fully paid department in 1911— about the time the photo was taken—

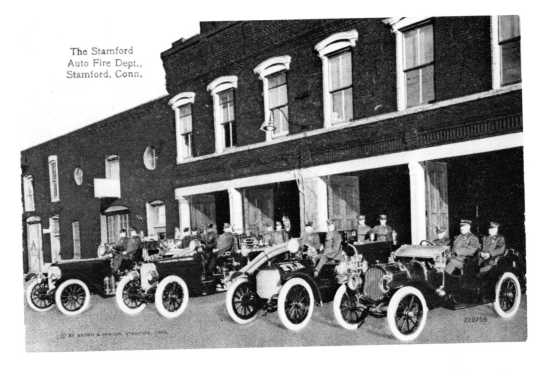

The Stamford Auto Fire Dept., Stamford, Conn.

were on Advocate Place. Here we see what appear to be two pumpers, a chemical engine, and the chief's car. By 1916, headquarters were at Main and Elm. Harry W. Parker was chief. *Refs.:* Sherwood, Herbert F. *The Story of Stamford.* New York: 1930. Stamford city directories: 1911, 1913, and 1916.

25. WATERBURY, CONNECTICUT.

Waterbury's first steam engines were Silsbys of 1880 and 1883, rebuilt in 1895 and 1902, respectively. Here we probably see the next Waterbury steamer: a first-size Metropolitan of 1902. The Brooklyn engine house was established in the next year, and the horse-drawn steamer served there until replaced by a gasoline-powered American LaFrance pumper in 1913.

Samuel C. Snagg, who joined the fire department in 1868, became chief of the volunteers in 1882. For the next 32 years, Snagg governed an agency that moved from volunteer to paid personnel, and from horse-drawn to motorized vehicles. In the 1910 period, Edward Kane served as Captain of Engine Three. *Refs.:* Anderson, Joseph, ed. *The Town and City of Waterbury.* New Haven, 1896. Mattatuck Historical Society. *Waterbury, 1674–1974.* Chester, CT: 1974. Pape, William J. *History of Waterbury and the Naugatuck Valley, Connecticut.* Chicago: 1918. Walker, Harold S. and Edward R. Tufts. *List of Silsby Steam Fire Engines 1858–1900.* Unpublished: 1975.

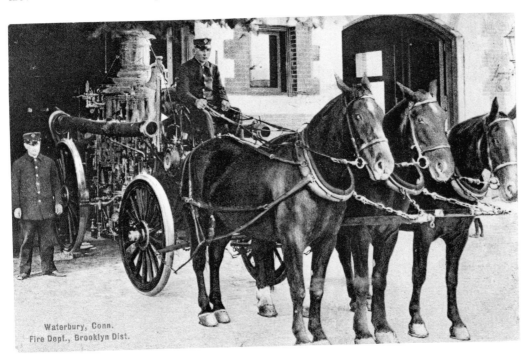

Waterbury, Conn. Fire Dept., Brooklyn Dist.

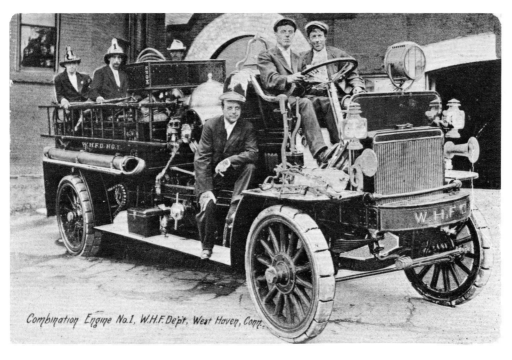

26. WEST HAVEN, CONNECTICUT.
This Knox lacked headlights. The dash-mounted kerosene lamps cast no beams and served as markers. When illumination of the streets from this pumper was required in West Haven, the searchlight, fueled by the acetylene tank beside the driver's foot, sufficed. Otherwise, low road speed probably allowed safe passage on the way to the fire scene, where the searchlight had its greatest use.

Note the pressure dome of a piston pump, the chemical tank below the dome, the hard suction hose over the rear wheel, both pneumatic and mechanical horns, and a proud crew. The West Haven Fire Department in 1911 was directed by Charles A. Cameron. Captain of Engine Company Number One was James Cannon. *Ref.*: West Haven city directory: 1911.

27. WINSTED, CONNECTICUT. Could these be the Winchester town selectmen looking over their new American-LaFrance Type 5 combination hose-and-chemical engine of 1910? The nickel-plated chemical tank is prominent under the driver's seat. Other plated components include the vertical fire extinguishers on the running board, the horizontal acetylene tank, and the gas-fueled searchlight. Note the tire chains on the rear wheels. *Refs.*: American-LaFrance Fire Engine Company, Inc. *Sales List to May 31, 1927.* Winsted city directory: 1916-1917.

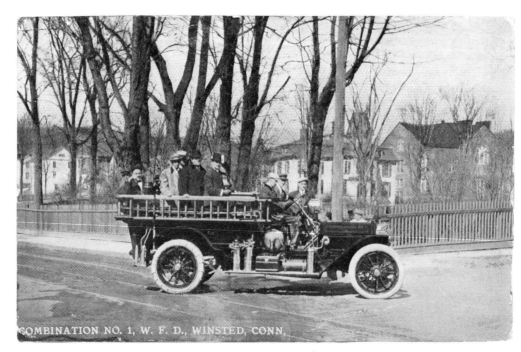

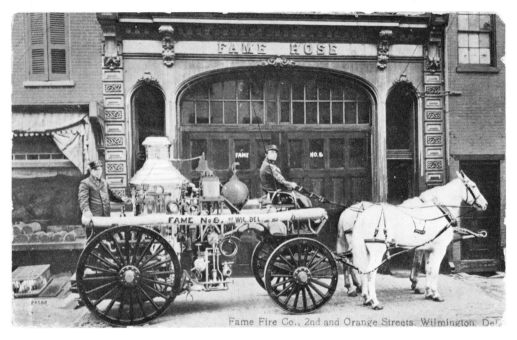

Fame Fire Co., 2nd and Orange Streets, Wilmington, Del.

28. WILMINGTON, DELAWARE.

Fame Hose, organized in 1839, acquired its new LaFrance steamer in 1894. A Silsby hose carriage complemented the engine. In addition, the volunteer company (except for drivers) maintained three horses. A boiler in the three-story station hose kept five pounds of steam pressure circulating in the engine at all times when it was parked in the building.

By 1911, the volunteer Wilmington fire department of 1,148 men ran twelve steam engines (including a self-propelled machine), 31 other fire vehicles, and an ambulance. *Refs.*: "Every Evening." *History of Wilmington*. Wilmington, 1894. Wilmington city directory: 1911.

29. WASHINGTON, DISTRICT OF COLUMBIA. The copyright date on this postcard indicates that this was one of the earliest Seagrave self-propelled vehicles. An air-cooled, four-cylinder engine powered the rear wheels through

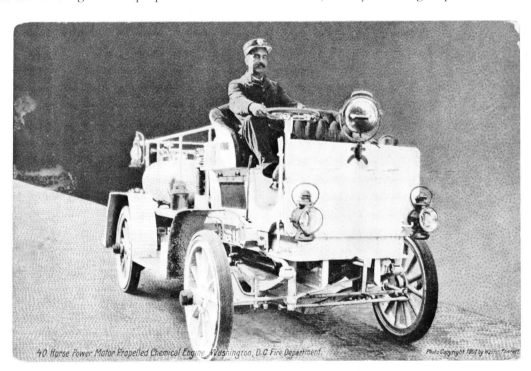

40 Horse Power Motor Propelled Chemical Engine, Washington, D.C. Fire Department. Photo Copyright 1907 by Walton Fawcett.

chain drive. One of two longitudinally mounted chemical tanks is visible in the bed. The lens of the dashboard-mounted searchlight was turned away from the camera when the photo was snapped. *Ref.*: McCall, Walter P. *American Fire Engines Since 1900*. Glen Ellyn, IL: 1976.

**30.
WASHINGTON,
DISTRICT OF
COLUMBIA.**

Hyattsville,
Maryland, was the
actual site of the
Washington car
factory from 1909
to 1912. The chief's
car likely joined
the equipment
roster in 1910 or
early 1911, so the
car was either a
1910 or 1911
model Washington.
Both had four-
cylinder engines,
three-speed

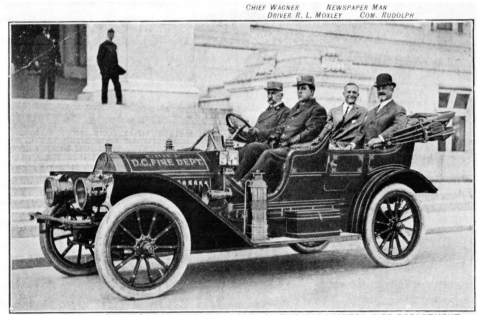

CHIEF WAGNER NEWSPAPER MAN
DRIVER R. L. MOXLEY COM. RUDOLPH

A WASHINGTON (STOCK) TOURING CAR ADOPTED BY THE WASHINGTON FIRE DEPARTMENT
CHIEF WAGNER AT WHEEL, COMMISSIONER RUDOLPH AT RIGHT, REAR SEAT

transmissions, and shaft drive to the rear wheels.

 In 1911, the District fire department had 17 engines, 13 extension ladder trucks, 13 hose carriages, 17 hose- and-
chemical wagons, and 1 wreck wagon—all operated by 459 men and 240 horses in 35 station houses. Fire Chief
was Frank J. Wagner. Cuno H. Rudolph was one of three fire commissioners; Owen R. Moxley was the chief's
driver. *Refs.*: Kimes, Beverly Rae and Henry Austin Clark, Jr. *Standard Catalog of American Cars 1805–1942.* Iola,
Wisconsin: 1985. Washington, D. C., city directories: 1908–1912.

31.

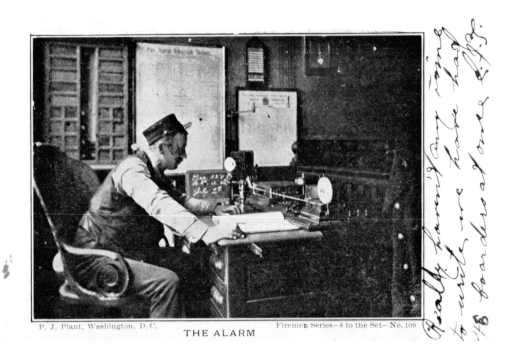

P. J. Plant, Washington, D. C. Firemen Series—8 to the Set—No. 109

THE ALARM

31.–38. WASHINGTON, DISTRICT OF COLUMBIA. The P. J. Platt postcard series took liberties with the clock as well as with daylight and darkness; nevertheless, these staged poses show us the steps that took firemen from sleep to a fire. In Card 31, the alarm sent from box 524 has been received, and the operator has recorded it on a chalkboard. He also has a record on the paper tape in front of him, punched with a series of holes in groups of five, two, and four.

In Card 32, at Engine Company Number Four on Virginia Avenue, the alarm bell has roused the sleeping firemen. In card 33, pulling on their trousers, they head for the brass pole upon which they slide to the apparatus floor below. The sleeping room clock shows 3:15; but in the next card, the clock indicates 2:50. In the foreground, the firemen are hitching a team of horses to the hose wagon. A few seconds later, in Card 35, the men have put on their turn-out gear and mounted the wagon. In Card 36, both the hose wagon and the steam engine head towards the alarm box. The engineer has ignited the fire under the engine boiler, so we see smoke in the chimney.

In Card 37, another horse has joined the team we saw in the previous picture. And Budweiser beer gets an advertisement in the heavy retouching. Finally, in Card 38, the fire scene has been reached and the steamer parked, connected by suction hose to a hydrant and by delivery hose to the firemen battling the blaze. The hose wagon, as well as the steamer's horses, have been taken a safe distance from the fire. *Refs.:* Washington, D. C., city directories: 1906 — 1908.

32

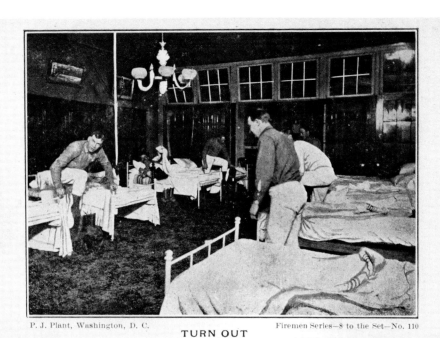

P. J. Plant, Washington, D. C. Firemen Series—8 to the Set—No. 110
TURN OUT

33.

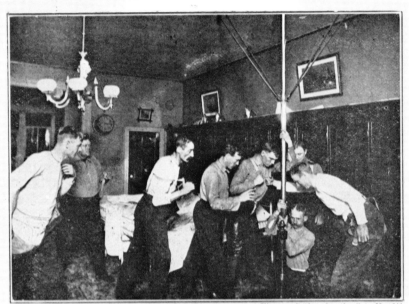

P. J. Plant, Washington, D. C. Firemen Series—8 to the Set—No. 111
DOWN THE POLE

34.

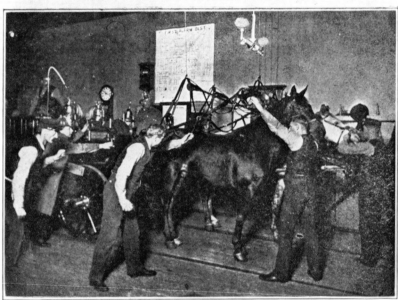

P. J. Plant, Washington, D. C. Firemen Series—8 to the Set—No. 112
HOOK UP

35.

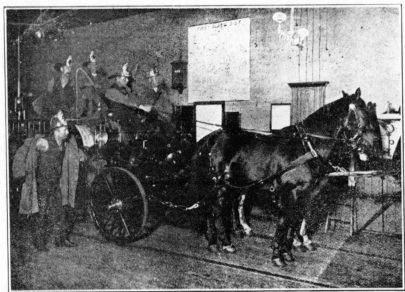

P. J. Plant, Washington, D. C. Firemen Series—8 to the Set—No. 113

READY!

36.

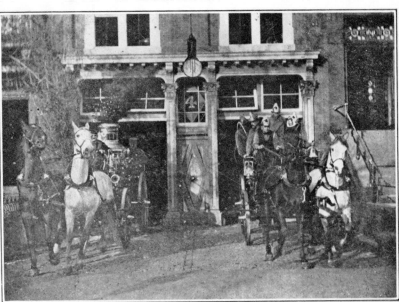

P. J. Plant, Washington, D. C. Firemen Series—8 to the Set—No. 114

START

37.

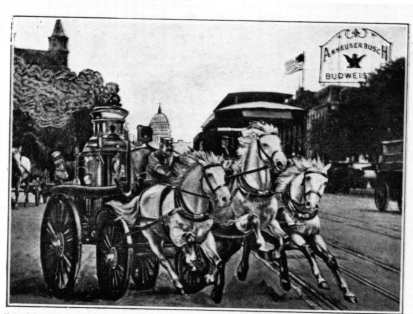

Copyright, 1906, by P. J. Plant, Washington, D. C. Firemen Series—8 to the Set—No. 115

ON THE WAY

38.

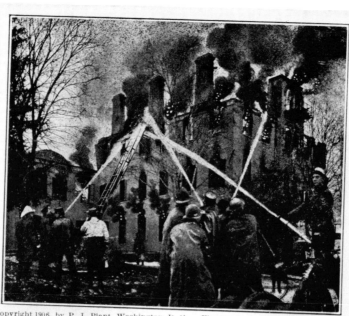

Copyright 1906, by P. J. Plant, Washington, D. C. Firemen Series—8 to the Set— No. 116

FIGHTING THE FIRE

39. JACKSONVILLE, FLORIDA.

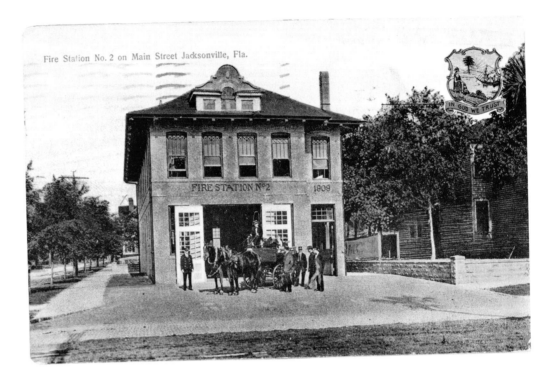

Fire Station No. 2 on Main Street Jacksonville, Fla.

Jacksonville's first organized fire company was Friendship Hook and Ladder in 1868. In 1886, a paid department supplanted the volunteers, and a Gamewell alarm system became operational.

At the turn of the century, a central station and three satellite buildings housed the fire department. Station Two, in the Springfield section of the city, occupied this new building on April 28, 1909, on Main Street at the corner of Fourth. The foreman was John C. Rousseau. Chief of the department since 1892 was Thomas W. Harvey. *Refs.*: Davis, T. Frederick. *History of Jacksonville, Florida and Vicinity, 1513–1924.* Jacksonville: 1925. Jacksonville city directories: 1909, 1910, and 1912.

40. MIAMI, FLORIDA. The concrete headquarters building at 436-438 Twelfth Street was built in 1907 at a cost of $15,000. At that time, Henry R. Chase, "the youngest chief in the U. S. A." (Muir), presided over seven paid men and twenty volunteers. A second-size American-LaFrance steamer, the "Dan Hardie" (named for a former chief and Dade County sheriff), was Miami's first steamer. Motorized apparatus reached the young city (incorporated in 1896 with the fire department organized in 1899) in 1911 when the department was as "good as any in the South" (Muir). *Refs.*: American Guide Series. *Miami and Dade County.* Northport, NY: 1941. Buchanan, James E., ed. *Miami.* Dobbs Ferry, NY: 1978. Miami city directories: 1914. Muir, Helen. *Miami, U. S. A..* New York: 1953.

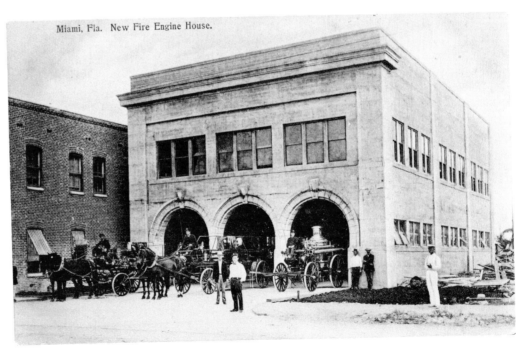

Miami, Fla. New Fire Engine House.

Fire Department of Pensacola, Fla.
Chief Bicker and 1st Ass't Chief Riera in buggy to left.

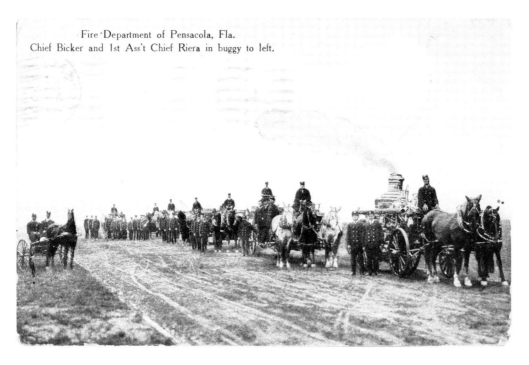

41. PENSACOLA, FLORIDA.

In 1913, William C. Bicker was chief, and Halcott Riera was assistant chief of the paid Pensacola Fire Department. Thirty other men rounded out the roster. In six companies, they operated apparatus that included a hook-and-ladder truck and four hose wagons. Pensacola bought a Silsby steam engine in 1891. *Refs.*: Pensacola city directories: 1907 and 1913. Walker, Harold S. and Edward R. Tufts. *List of Silsby Steam Fire Engines 1858-1900.* Unpublished: 1975.

42. BOISE, IDAHO. Boise's organized fire protection began in 1863 with the founding of the Idaho Hook and Ladder Company. A water tank on East Hill pressurized the fire hydrants. Firemen on the fire ground reportedly used leather hose that probably was attached directly to the hydrants. This postcard likely dates from the early twentieth century, shortly after Boise switched to a paid department in 1902. *Refs.*: Hart, Arthur A. *Fighting Fire on the Frontier.* Boise: 1976.

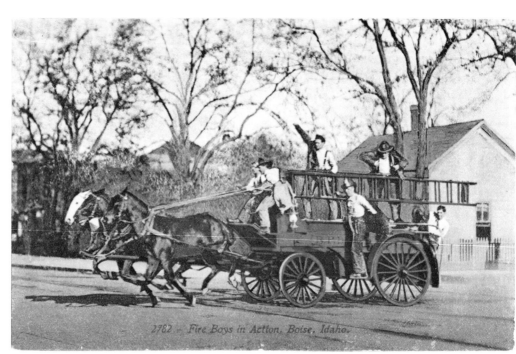

2782 - Fire Boys in Action, Boise, Idaho.

43. TWIN FALLS, IDAHO.

This Twin Falls photo depicts a first-class fire company at the end of the horse-drawn apparatus era. To the left, we see the ultimate steam fire engine design: a crane-necked, short wheelbase machine with vertical steam and pump cylinders. The three-horse hitch provided speed and power. On the right is a combination hose-wagon-and-chemical-engine.

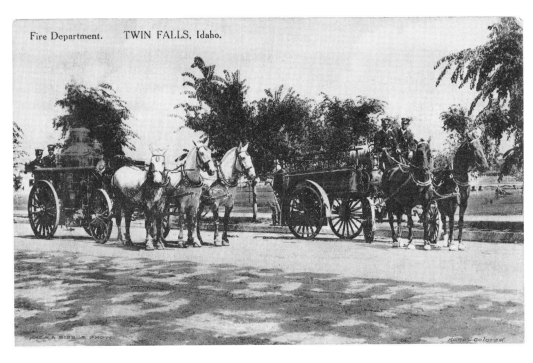

Fire Department. TWIN FALLS, Idaho.

The chemical tank below the seat and its hose behind the seat produced a quick stream on the fire scene, pending hook-up of the steam engine and its delivery hose from the bed of the wagon.

44. BELLEVILLE, ILLINOIS.

The Belleville Fire Department probably relied upon the pressure of its water mains to fill the fire hoses. If a steam engine had been on the equipment roster, it certainly would have had a prominent place in this postcard view. Instead, we see the chief's buggy with a gong on the dashboard on the left, a hose reel in the center, and a hook-and-ladder truck at the right.

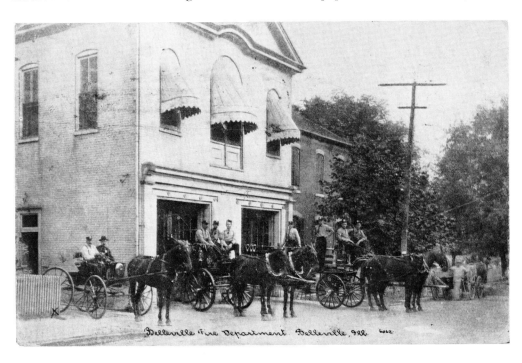

45. CHICAGO, ILLINOIS.

In 1908, Chicago's fire department was a large organization. Fire Marshall James Horan supervised 1,615 men in 17 battalions. In addition, 615 horses were available to pull apparatus. Equipment included 116 steam engines (one of which we see here on the left), 114 hose wagons (second from left), 1 water tower, 24 chemical engines, 8 chemical extinguishers (third from left; note the huge diameter of the wheels), 33 hook-and-ladder trucks (in the rear along the right hand wall behind its swinging harness), and 3 river fireboats. A separate fire insurance patrol worked in eight companies. *Ref.*: Chicago city directory: 1908.

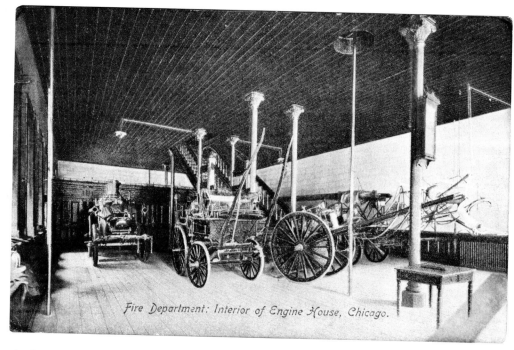

Fire Department: Interior of Engine House, Chicago.

46. EAST ST. LOUIS, ILLINOIS.

Here, apparently, is an engine house without an engine. We expect to see a steam engine or at least spot the chemical engine that the sign on the right side of the building claims is stationed here. Perhaps either the ladder truck or the hose wagon has chemical equipment that we cannot see in this tiny image. Certainly, it is peculiar to see the hook-and-ladder in the doorway of an engine house, but fire departments are known to move equipment around to fit changing needs.

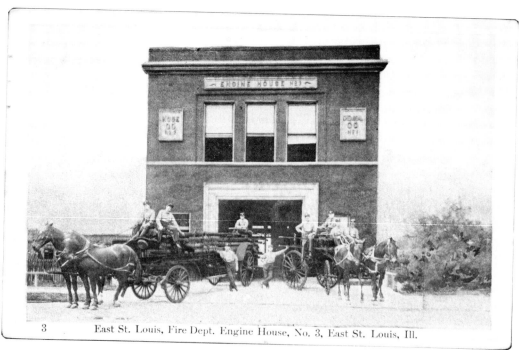

3 East St. Louis, Fire Dept. Engine House, No. 3, East St. Louis, Ill.

47. FREEPORT, ILLINOIS.

Freeport ordered this apparatus from the Seagrave factory in Columbus, Ohio. The photo for this postcard, taken about 1912, shows two combination chemical-and-hose units at the center and right as well as an aerial truck

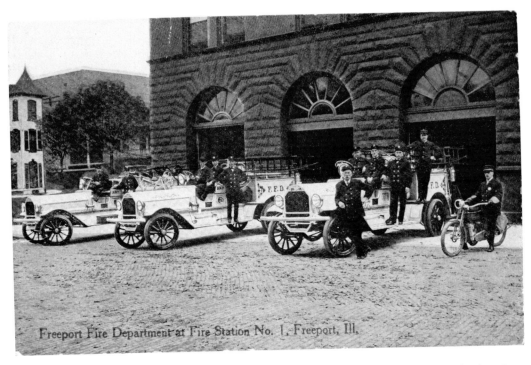

Freeport Fire Department at Fire Station No. 1, Freeport, Ill.

at the left (surmised from the small portion of the vehicle visible). While the Seagraves were fitted with electric head and searchlights, the motorcyclist rode behind an acetylene lamp.

48. URBANA, ILLINOIS. On the evidence of this postcard view, we could hypothesize that in about 1910 (a date based on the architecture and clothing), Urbana's fire department was a volunteer organization (lack of uniforms)

that relied upon a pressurized water system (absence of an engine) to put water through the hose carried on the wagon. The hook-and-ladder truck also carried hose, probably for a chemical tank that may have been the shiny object under the seat.

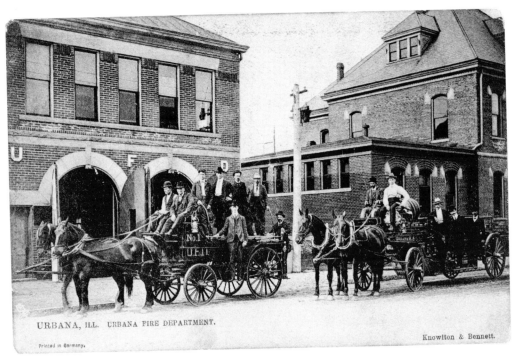

URBANA, ILL. URBANA FIRE DEPARTMENT.

Knowlton & Bennett.

Printed in Germany.

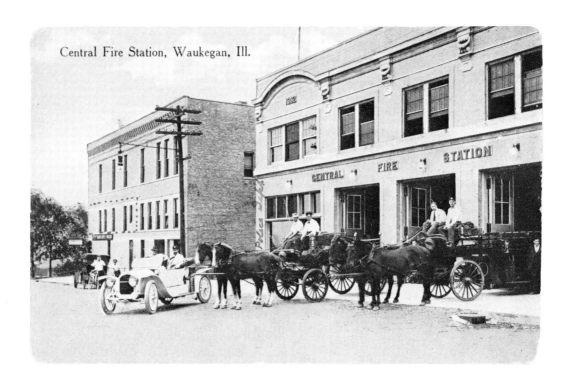

Central Fire Station, Waukegan, Ill.

49. WAUKEGAN, ILLINOIS. This northern Illinois city dedicated its new fire house in 1912—about the time the photo for this postcard was made. We see what was probably the entire apparatus roster: a car for the chief, a hose wagon, and a ladder truck. Ten years later, Sors O'Farrell served as chief. The remainder of the paid department consisted of an assistant chief, two captains, seven pipemen, a truckman, four drivers, and a call man. *Refs.*: Waukegan city directory: 1922.

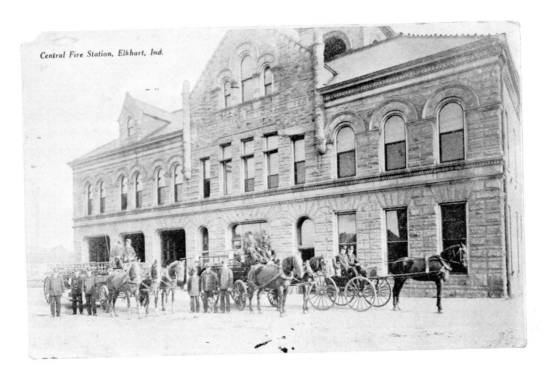

Central Fire Station, Elkhart, Ind.

50.—51. ELKHART, INDIANA. Here are two views of the central police and fire station. The first, Card 50, was made close to the year of construction in 1895. We see a ladder truck, a hose wagon, and the chief's buggy. In the second picture, a Webb piston pumper and a Seagrave ladder truck have replaced the horse-drawn apparatus. It is likely that a number of steam engines were still in operation at that time—about 1911. By 1922, the fire department was fully motorized. *Refs.*: Chamber of Commerce, *From Elkhart on the Old St. Joe.* Elkhart, 1922. Elkhart city directory: 1912.

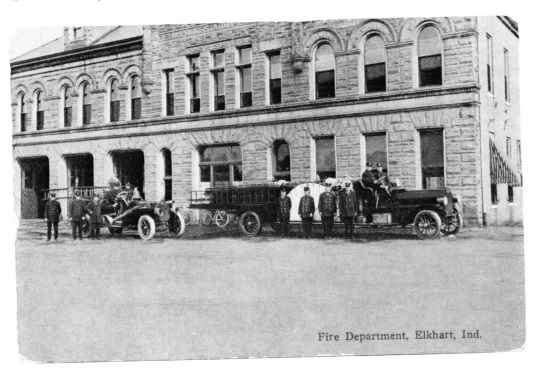

Fire Department, Elkhart, Ind.

7404. Headquarters of Fire Department, Indianapolis, Ind.

52. INDIANAPOLIS, INDIANA.

The paid Indianapolis fire department dates from 1858 when an early rotary steam engine was used. Here is a postcard from near the end of the steam era. In the center is a large-capacity engine—perhaps one of the extra first Americans received in 1901—with a dog sitting beside the driver. Flanking the steamer are a hose wagon and a Champion water tower, which was a 75-foot affair built in 1895 and, reportedly, the tallest tower in the United States. *Refs.*: Hass, Bill. *History of the American Water Towers.* Sunnyvale CA: 1988. Leary, Edward A. *Indianapolis: Story of a City.* Indianapolis: 1971.

53. RUSHVILLE, INDIANA. The distinctive handwritten labels on this card and the Belleville, Illinois view (Card 44) indicate that both were published by Hargrove and Mullen, who may have taken many other mid-Western fire

department portraits.

Rushville probably had a volunteer department, judging from the casual appearance of the men on the wagon. Perhaps it was the middle of a workday with too few hands available to bring out the steamer; its boiler is shining inside the station.

54.–55. VALPARAISO, INDIANA. Postcards 54 and 55 show us the same hose wagon and the same fire house in two very different views. In Card 54, note the fire bell in an iron tower atop City Hall. In Card 55, see the quick harness in front of the hose wagon, the ladder truck on the left, the horse in the stall at the left rear, the brass pole at the right rear, and the convention banner for the Northern Indiana Volunteer Firemen's Association.

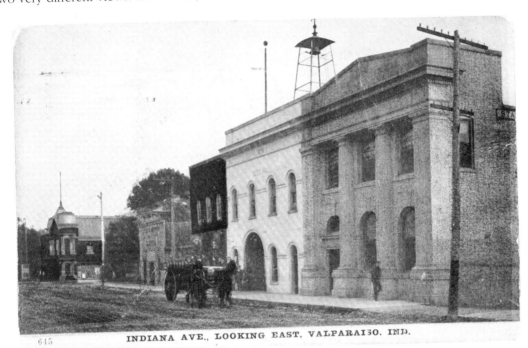

645 INDIANA AVE., LOOKING EAST, VALPARAISO, IND.

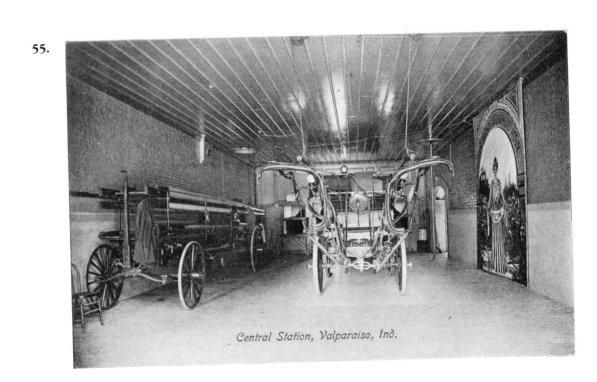

55.

Central Station, Valparaiso, Ind.

56.–57. CLINTON, IOWA. We assume that the International Correspondence Schools with headquarters in Scranton, Pennsylvania, had no direct connection to the muster team. These men, horses, and wagon probably entered races that had the rig driven over a course followed by a rapid hose connection. A work-a-day hose wagon appears in the center of the other Clinton view, between the officer's buggy and a ladder truck.

Compliments of INTERNATIONAL CORRESPONDENCE SCHOOLS

M. W. ROWE, Local Manager. Office, Howes Block, Clinton, Iowa. Both Phones

CLINTON, IOWA, FIRE TEAM BEAUTY BONNIE
Firemen's Tournament, July 27-1, 1908. Over 4000 students placed in good positions last year

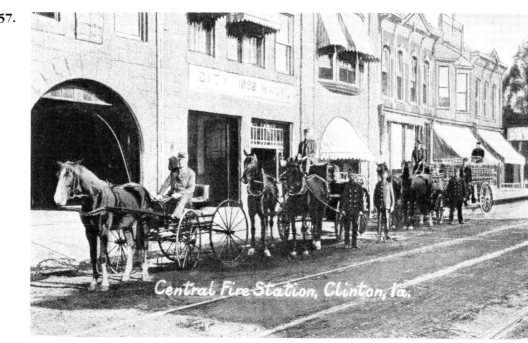

57.

Central Fire Station, Clinton, Ia.

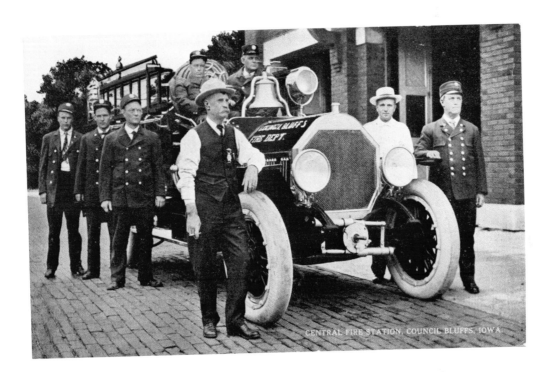

CENTRAL FIRE STATION, COUNCIL BLUFFS, IOWA

58. COUNCIL BLUFFS, IOWA. In 1913, Charles M. Nicholson was chief of the Council Bluffs Fire Department. His central station was at the corner of Main Street and Washington Avenue. Hose Company Number Three was assigned to that house, but whether Number Three ran this Webb chemical combination is unclear. There is no uncertainty about the pride of the firemen in their rig. *Refs.*: Council Bluffs city directories: 1907, 1911–1913, and 1919. McCall, Walter P. *American Fire Engines Since 1900.* Glen Ellyn, Illinois: 1976.

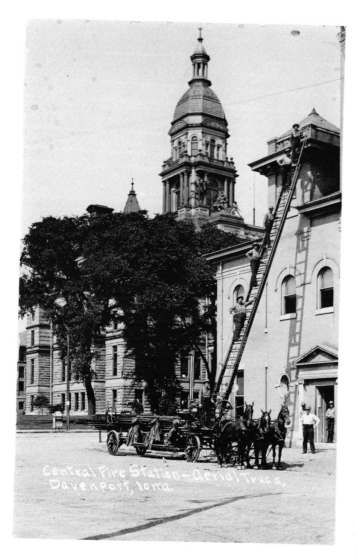

Central Fire Station—Aerial Truck,
Davenport, Iowa.

59. DAVENPORT, IOWA. Hook and Ladder Company Number One proved that the weight of five men was not too much for its aerial. Gustav G. Alex was captain of the company, which shared quarters at the corner of Fourth and Scott with Hose Company Number Two in 1912. In all, the Davenport depart-ment had 47 men, 22 horses, 1 automobile, 2 trucks, 7 hose-and-chemical wagons, and 8 hose carts in seven stations. Real estate value was $100,000, and the apparatus was valued at $64,650. *Ref.*: Davenport city directory: 1912.

60. KEOKUK, IOWA. Apparently, a municipal water system allowed Keokuk to rely on hose carriages and carts for its fire apparatus protection about 1910. Buggies assured the officers' quick response to alarms. Earlier, in 1876, two steam engines, a hand engine, and four Champion extinguishers "mounted on trucks" served the firemen. *Ref.*: Keokuk city directory: 1876.

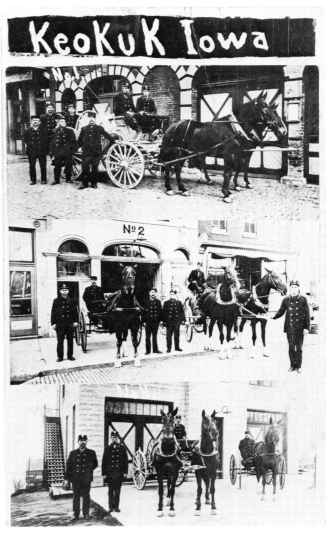

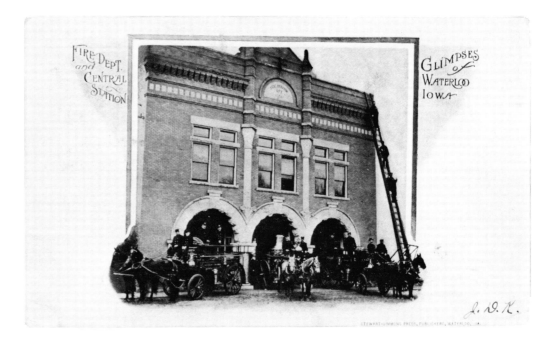

61. WATERLOO, IOWA.

Our glimpse of Waterloo's central fire station, circa 1905, actually shows four pieces of apparatus. In addition to the two combination chemical-and-hose wagons and the steam engine, note the wheel and extended ladder of an aerial truck.

62. ATCHISON, KANSAS. Atchison's fire headquarters were at 217–219 North Sixth Street. Equipment in the 1900's included an air-cooled roadster (similar to an early Franklin) for the chief, a hose wagon with rear wheels of a very large diameter, a hook-and-ladder truck with rear tiller, and a Silsby steamer. The last item, delivered in 1873, was rebuilt with a Fox water tube boiler in 1900. Notice the wrap-around suction hose. *Refs.*: Atchison city directory: 1913. Walker, Harold S and Edward R. Tufts. *List of Silsby Steam Fire Engines 1858–1900.* Unpublished: 1975.

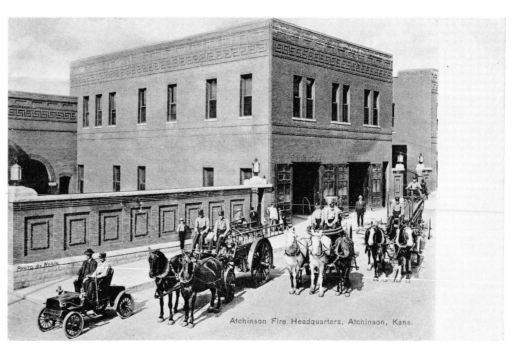

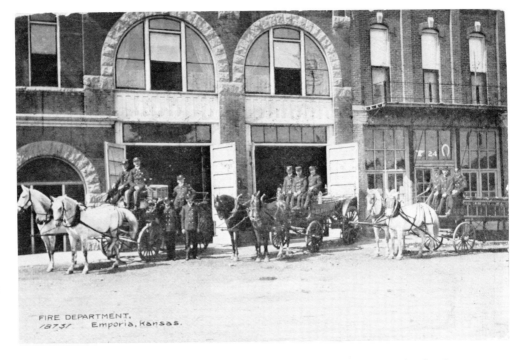

63. EMPORIA, KANSAS.

A combination chemical-and-hose wagon, a straight hose wagon, and a ladder truck appear in this postcard view. We assume that there were no steam engines in the municipality when the original photo-graph was taken. Note the anvil and horseshoe signs for the blacksmith located next door to the fire house—a convenient arrangement for the fire department horses.

64. LOUISVILLE, KENTUCKY. The Louisville Fire Department operated 21 steamers in 1910, including at least five Ahrens engines built in nearby Cincinnati, Ohio. A hose wagon for each engine, five ladder trucks, and a water tower rounded out the equipment roster. Direction came from Chief Thomas Lehan and four assistant chiefs, one of whom may appear at the extreme right of the postcard. *Refs.:* Louisville city directories: 1905, 1910, and 1913.

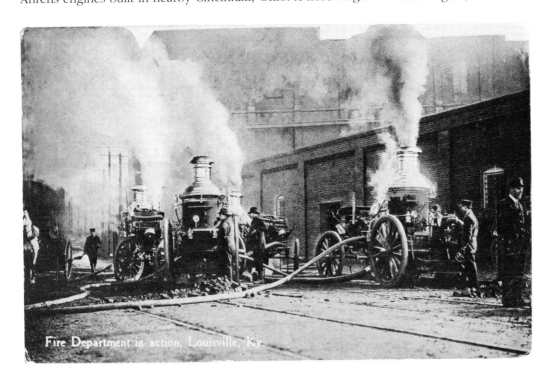

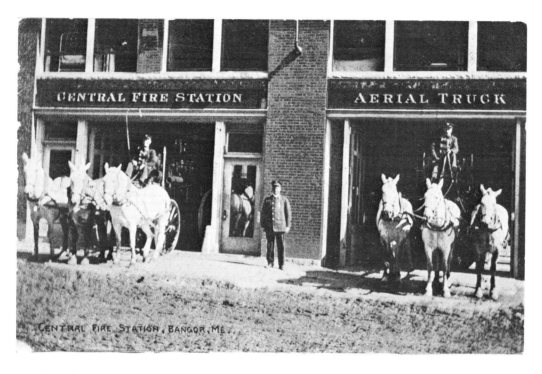

CENTRAL FIRE STATION, BANGOR, ME.

65. BANGOR, MAINE.

In the mid-1890's, Bangor's fire department consisted of three steamer companies, four hose companies, and a hook-and-ladder company. In 1898, the department responded to 131 alarms with a total property loss of $53,612. This postcard, probably of Engine Number Three and the aerial truck, dates from the 1900's. Note the bed in the sleeping quarters above the engine. *Refs.*: Bangor city directories: 1895, 1898, 1899, and 1921.

66. BANGOR, MAINE. "Combination" here refers to a joining of a hook-and-ladder function with that of a chemical engine. Note the "CHEMICAL" lettering on the box behind the left front wheel. The well-equipped truck had a fender behind the horses' hoofs to protect the chemical tank, as well as mud guards over the wheels.

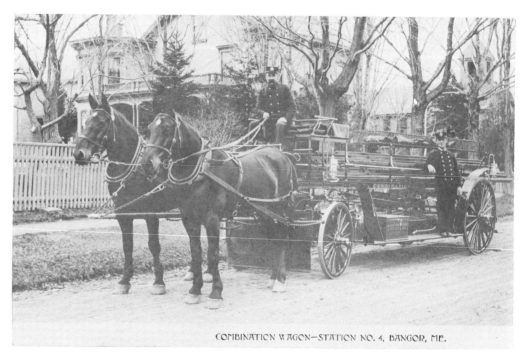

COMBINATION WAGON—STATION NO. 4, BANGOR, ME.

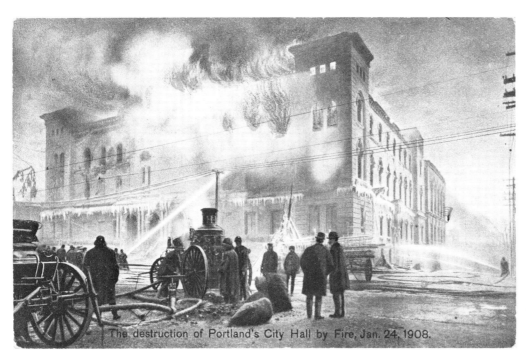

The destruction of Portland's City Hall by Fire, Jan. 24, 1908.

67. PORTLAND, MAINE.

Portland City Hall suffered initial damage in the great fire of 1866. Rebuilt, it was destroyed by the conflagration seen here. However, a new structure arose in the 1910's; like its predecessor, the new City Hall contained a public theater that hosted the world's leading performers.

In 1908, the Portland Fire Department operated nine steam engines with accompanying hose wagons, two additional hose wagons, and five ladder trucks. *Refs.*: Hull, John T. *Handbook of Portland.* Portland: 1888. Moulton, Augustus F. *Portland by the Sea.* Augusta: 1924. Portland city directory: 1908. Writers' Program. *City Guide.* Portland: 1940.

68. PORTLAND, MAINE. In 1907, Portland's self-propelled Amoskeag steamer operated as Engine Five from quarters shared with Chemical One at Congress and Market Streets in the central station. James T. Rollinson was tillerman; Peter S. Dole, engineman; and Howard A. Fogg, stoker. Colleagues included Captain Almus D. Butler, Lieutenant Frank P. Carr, Driver of Chemical John H. Black, and Driver of Hose Charles H. Mayberry. *Refs.*: *Amoskeag Steam Fire Engines.* Philadelphia, 1895; rpt. Manchester: 1974. Portland city directories: 1883, 1895, 1900, and 1907.

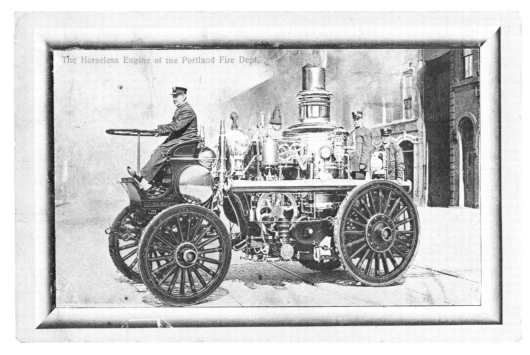

The Horseless Engine of the Portland Fire Dept.

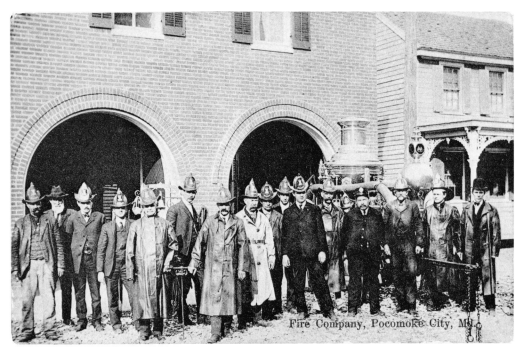

69. POCOMOKE CITY, MARYLAND.

With helmets over business suits, these men, mostly middle-aged, are probably members of a volunteer company gathered for a workday group portrait. Perhaps the uniformed man (fourth from right) is a paid driver. The apparatus on the left is a hand-drawn hose reel. On the right is likely the horse-drawn Clapp and Jones engine that Pocomoke City purchased new in 1888. *Ref.*: Walker, Harold S. *Partial List of Clapp and Jones Steam Fire Engines.* Unpublished: 1974.

70. ARLINGTON, MASSACHUSETTS. It is parade day in Arlington with visiting firemen in the line. The steam engine is probably from a nearby department. In 1907, Arlington had no engines "because of the excellent high- and low-pressure water systems." A 100-pound pressure pipe ran down one side of the street and a forty- to fifty-pound line on the other. Hose wagons, a chemical, and a ladder truck served as Arlington's apparatus. *Ref.*: Pierce, Warren A. "Arlington Fire Department." Charles S. Parker. *Town of Arlington Past and Present.* Arlington: 1907.

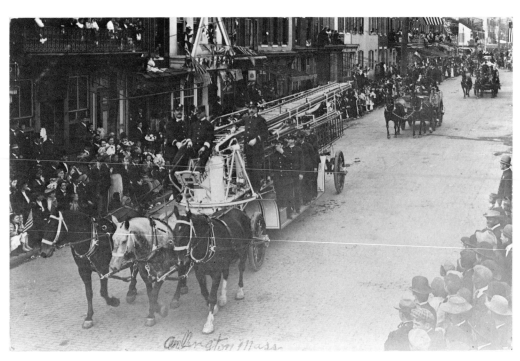

**71. BOSTON
(AND CHELSEA),
MASSACHUSETTS.**
The great
Chelsea fire of
1908 began at the
Boston Blacking
Company factory
in an area of rag
shops. Before it
was over, eighteen
people were dead,
3,500 buildings on
275 acres were
destroyed, and
losses totaled
$12,000,000. In
fighting the blaze,
the Chelsea Fire
Department was
aided by men and
equipment from

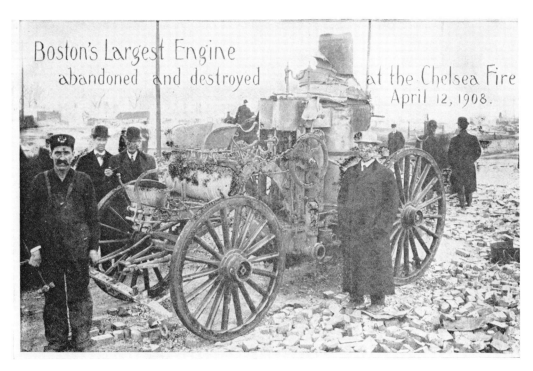

eleven other municipalities. High winds contributed to the fire's spread; and an hour after going into operation, this
Amoskeag engine was overrun by the flames. Altogether, three Boston engines were lost. And when the fight was
over, the Chelsea had fifty babies to return to parents from whom they had been separated. *Refs.*: Boston city
directory: 1908. Lyons, Paul R. *Fire in America. Boston: 1976. New York Times.* April 13 and 14, 1908.

72. BROOKLINE, MASSACHUSETTS. The chief of the Brookline Fire Department in 1906 — and since 1878 — was
George H. Johnson. He and his colleagues seen here operated two steam engines, 36 horses, and "a plentiful

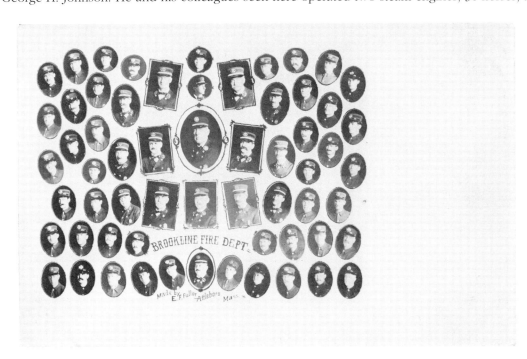

supply of hose,
ladders, combination
trucks, chemical
engines, etc."
(*History of Brookline*)
from seven fire
stations. The wealth
of equipment is
understandable in
this fashionable
suburb of Boston,
called the "richest
town in the world"
(ibid.). *Refs.*: Bolton,
Charles K. *Brookline.*
Brookline: 1897.
Brookline Press. *A
History of Brookline,
Massachusetts.*
Brookline: 1906.

73. BUZZARDS BAY, MASSACHUSETTS.

This was a hook-and-ladder truck with chemical equipment visible behind the running board. Note the numbers painted on the ends of the ladders to indicate their lengths, a practice still common at this end of the twentieth century. Note, too, the mascot on the seat.

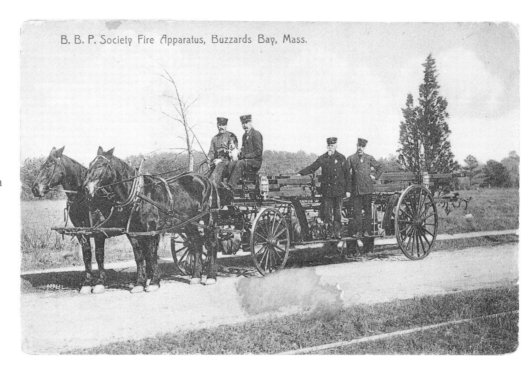

B. B. P. Society Fire Apparatus, Buzzards Bay, Mass.

74. CHICOPEE, MASSACHUSETTS. This first-size (a piston ten inches in diameter) hand engine was built in 1851 as "Pacific Number One" for the village of Waterloo, New York. Next housed in New London, Connecticut, it was renamed "New London." Then when it was acquired by the Chicopee Veteran Firemen's Association as a muster engine, it became the "City of Chicopee." After passing into the museum collection of the Society for the Preservation of New England Antiquities, the engine was stored for many years at the Jacobs Farm in Norwell, Massachu-

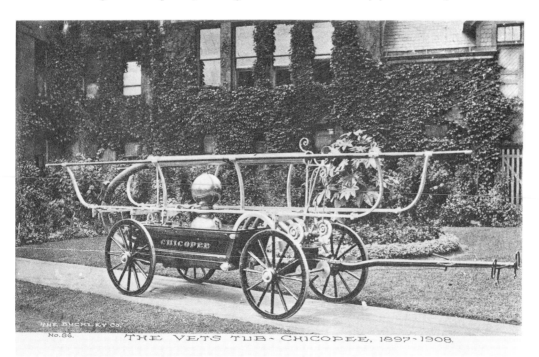

THE VETS TUB - CHICOPEE, 1897-1908.

setts. Then, in 1989, as the S. P. N. E. A. reduced its apparatus holdings, the "City of Chicopee" returned to Chicopee. *Refs.*: Dixon, Stan. Telephone interview. October 17, 1989. Walker, Harold S. (and Edward R. Tufts?). *Button Hand Engines.* Unpublished list: 1977(?).

75. CHICOPEE, MASSACHUSETTS. Fire Department Chief in the late 1900's and early 1910's was John E. Pomphret, probably standing in the center of this postcard scene. Theodore E. Savaria was foreman of Owego Hook and Ladder Company Number Two (truck on the left side of this view) in 1910. John A. McCarthy was foreman of Hose Company Number Three (right side). *Refs.*: Chicopee city directories: 1905, 1910, and 1915.

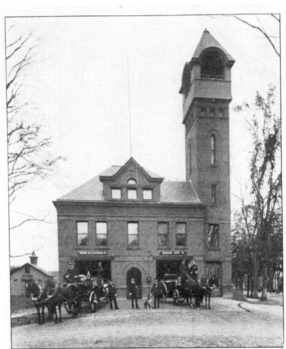

No. 3. Fire Department Headquarters, Chicopee, Mass.
F. M. Gilbert, Publisher.

76. FITCHBURG, MASSACHUSETTS.
Franklin Hook and Ladder shared these quarters at 17 Summer Street with Niagara Hose Company Number Four in the later 1890's. By 1904, Rollstone Hose had replaced Niagara.

William H. Hall served as foreman of the Franklin company at least until 1915. Driver in 1898 was Chauncey D. Ford, succeeded by James W. Fogarty. One or two additional

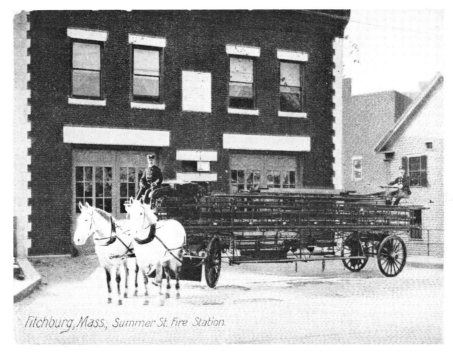

Fitchburg, Mass., Summer St. Fire Station.

officers and ten to twelve firemen made up the remainder of the Franklin squad during the 1898–1915 period.

The Gleason and Bailey aerial, purchased from the Seneca Falls, New York company in 1895, was replaced by a 65-foot Seagrave in 1926. *Refs.*: Fitchburg city directories: 1898, 1904, and 1915. Stolba, Ernest A. *Fitchburg, Massachusetts Fire Department 1825–1952.* Fitchburg, 1952.

77. FRAMINGHAM, MASSACHUSETTS. Impressive bunting decorates the station house in this postcard, but note also the helmets lined up atop the ladder truck. In 1908, Framingham, South Framingham, and Saxonville comprised the three districts of a fire alarm system. The Board of Engineers governing the Framingham Fire Department consisted of Edward C. Eames, an inspector for the telephone company; David F. (M.?) Gorman, who kept a stable; and Clifford B. Daniels, a dealer in automobiles and supplies. *Ref.*: Framingham city directory: 1908.

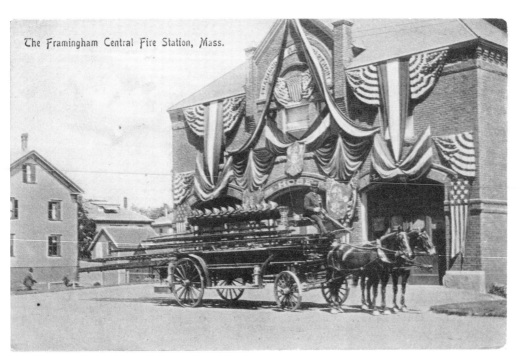

The Framingham Central Fire Station, Mass.

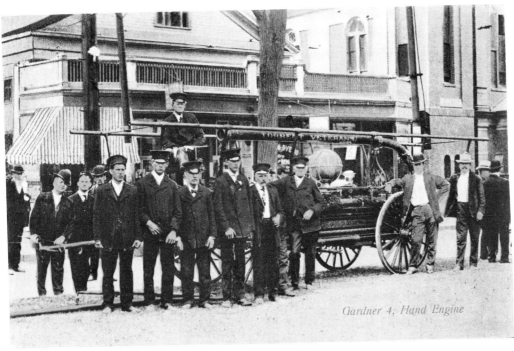

Gardner 4, Hand Engine

78. GARDNER, MASSACHUSETTS.

In its first 66 contests, Gardner won forty prizes, including eleven first places. Built by the Button Company of Waterford, New York, in 1882, Gardner Number Four held the world's record in 1901 with a throw of 241 feet 10 inches. Its own best distance—251 feet 11 inches, set in 1906—was no longer a record. In 1940, this first-size engine went to the Portland, Maine, Veteran Firemen's Association; and in 1964, to the West Newbury, Massachusetts, Volunteer Firemen's Association. The hand engine remains active today in the New England States Veteran Firemen's League musters. It has never fought a fire. *Refs.*: Dixon, Stan. Telephone interview. October 20, 1989. *New England States Veteran Firemen's League Muster Souvenir Treasure Book.* 1908.

79. GREAT BARRINGTON, MASSACHUSETTS.
The town of Great Barrington bought a two-cylinder steam engine in 1882 when the fire department had ten reservoirs and 21 hydrants supplying water. In 1907, the fire district acquired its own team of horses to tow the engine. The steamer was replaced by motor apparatus in 1922 with the ladder truck following in 1927. *Ref.*: MacLean, George E. *History of Great Barrington.* Great Barrington: 1928.

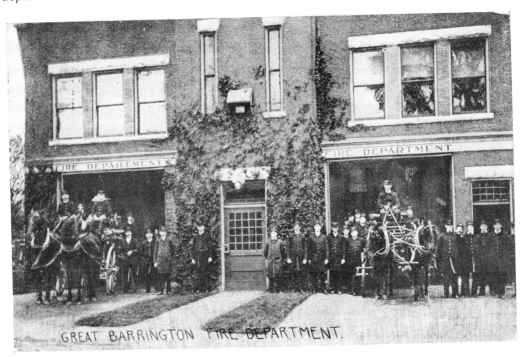

GREAT BARRINGTON FIRE DEPARTMENT.

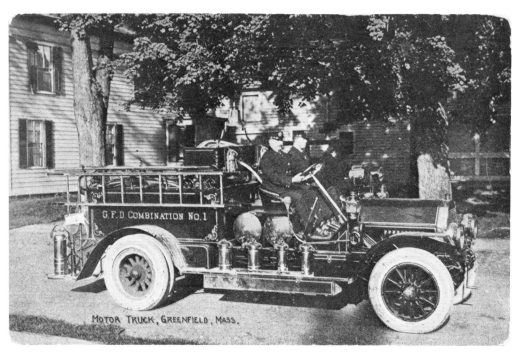

80. GREENFIELD, MASSACHUSETTS. This Knox combination hose-and-chemical engine was likely the first motorized apparatus in Greenfield, thereby earning a photograph for a postcard. The rig came to a fire department with two hose and one ladder companies, and probably was assigned to one of the hose units. Dual pneumatic tires in the rear provided security in case of puncture and better weight-carrying characteristics than single tires. *Ref.*: Greenfield city directory: 1910.

81. HAVERHILL, MASSACHUSETTS. This 1910 Knox combination hose-and-chemical car had the characteristic Knox lettering below the radiator and the running boards to identify the fire company. In Haverhill, its passage was announced by a bell, siren, or horn. The chains on the rear tires were useful on snowy, icy, or muddy roadways—the last not unusual in a period when many city streets remained unpaved. *Ref.*: McCall, Walter P. *American Fire Engines Since 1900*. Glen Ellyn, Illinois: 1976.

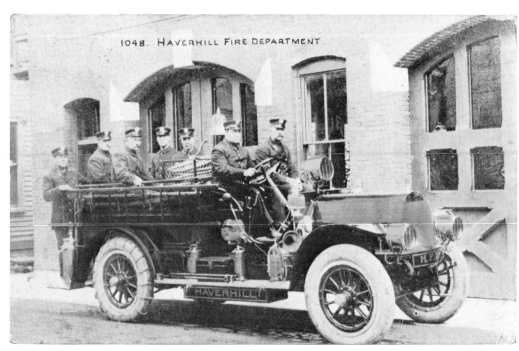

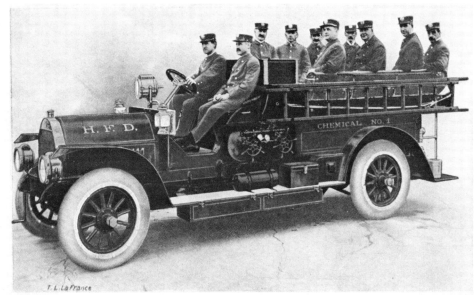

CHEMICAL NO. 1, FIRE DEPARTMENT, HOLYOKE, MASS.

82. HOLYOKE, MASSACHUSETTS.
In spite of the "LaFrance" notation printed on this card, this was a Knox combination hose-and-chemical auto acquired by Holyoke in 1911. It shared quarters with a first-size Button steam engine and its two-horse team as well as the chief's car at 310 High Street. *Refs.*: Holyoke city directories: 1910–1913 and 1917.

83. LOWELL, MASSACHUSETTS. Edward S. Hosmer received an annual salary of $2,200 in the 1909–1914 period. As chief, he directed a department of six steam engine companies, five hose companies, four truck companies (two

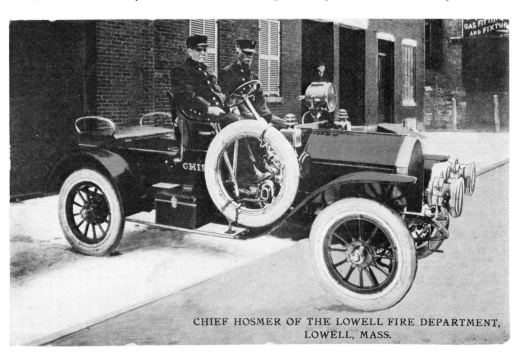

CHIEF HOSMER OF THE LOWELL FIRE DEPARTMENT, LOWELL, MASS.

with "chemical engines attached"), and one protective company. His driver was Harry B. Sanders, and his car was a Knox. The photograph for this card was made in front of fire head-quarters at Palmer and Middle Streets. *Refs.*: Lowell city directories: 1909–1914.

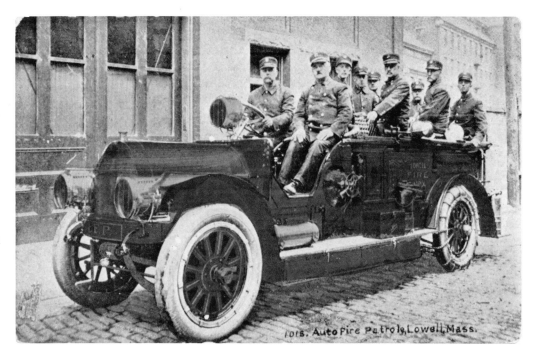

84. LOWELL, MASSACHUSETTS.

This is Protective Company Number One circa 1910 posed in their circa 1910 Knox. The driver (and clerk) is John J. Rinehart. Captain is William H. Halstead. Behind them are the six patrolmen assigned to the company. Notable equipment includes the chemical tank under the seat and the acetylene searchlight probably fueled by the tank on the running board. *Refs.*: Lowell city directories: 1909, 1910, and 1912.

85. LYNN, MASSACHUSETTS. In 1911, this station at 320 Broad Street housed Engine Number Four under Captain William H. Kelly, Ladder Number Three under Captain Herbert H. Robinson, and Chemical Number One under Lieutenant Walter F. Martin. In addition, Chief Engineer Thomas A. Harris with Driver Frederick W. Bacheller maintained their car here.

Steamer makes delivered to Lynn included Amoskeag, Button, and LaFrance. Perhaps the engine in the card was the LaFrance piston engine that went into service before 1893. *Refs.*: *Amoskeag Steam Fire Engines.* Philadelphia, 1895; rpt. Manchester: 1974. *The LaFrance Fire Engine Company Catalogue.* Elmira, NY (?): 1892. Lynn city directory: 1911. Walker, Harold S. (and Edward R. Tufts?). *Button Hand Engines.* Unpublished list: 1977.

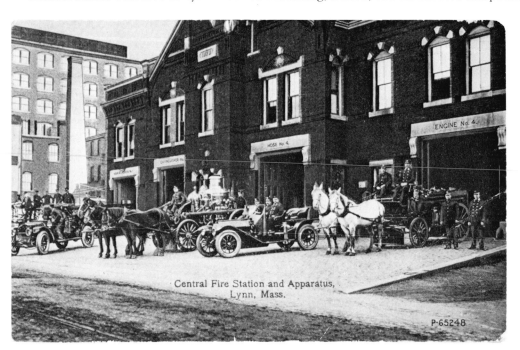

Central Fire Station and Apparatus, Lynn, Mass.

P-65248

86. MANSFIELD, MASSACHUSETTS.

Two independent companies merged to form the Mansfield Fire Department in 1898. Henceforth, apparatus was drawn by horses hired from the L. R. King and Son livery stable. Motorization began in 1910, and the last bill for horse hire was submitted in 1918.

In this postcard, we see a White pumper on hard rubber tires (left)

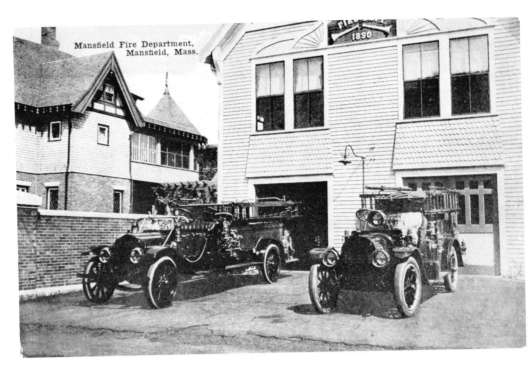

and, apparently, a Pope Hartford chemical-and-hose car on pneumatic tires (right).

Chief Engineer Herbert E. King retired in 1928 after thirty years of service. A new fire station for the volunteer department was built in 1930. *Refs.*: Copeland, Jennice F. *Every Day But Sunday.* Brattleboro, VT: 1936. Mansfield city directory: 1898.

87. NEW BEDFORD, MASSACHUSETTS. Motorization about 1907 in New Bedford brought what appears to be a Locomobile to Hose Number One. Number Three's wagon provided a strong contrast between new and old. Note also the three-horse team on the aerial. The central station was at 868 Pleasant Street. *Refs.*: Association of Licensed Automobile Manufacturers. *Handbook of Gasoline Automobiles.* New York: 1906. New Bedford city directory: 1923.

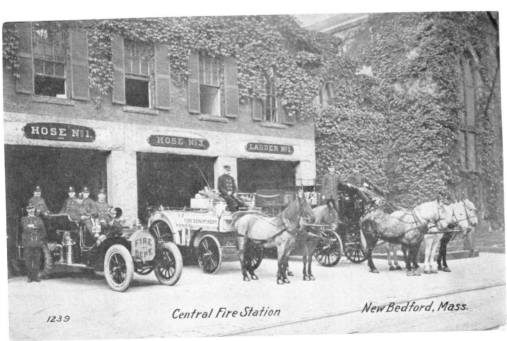

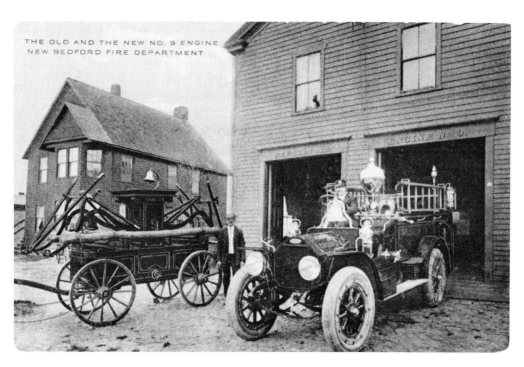

THE OLD AND THE NEW NO. 9 ENGINE
NEW BEDFORD FIRE DEPARTMENT

88. NEW BEDFORD, MASSACHUSETTS.

Another sharp contrast between old and new in the New Bedford fire department was between the new, circa 1910, Webb piston pumper and the Merrick and Agnew hand engine. The latter was purchased in 1843 from the Philadelphia builders for Hancock Engine Company Number Nine. At first, the Agnew was stationed on Foster Street near North Street. Later, in 1890, at Head of the River, it was the last hand engine in commission (steam had come to other sections of New Bedford in 1860). *Ref.:* Ellis, Leonard B. *History of the Fire Department of the City of New Bedford 1772–1890.* New Bedford: 1890.

89. NEWTON CENTRE, MASSACHUSETTS. Engine Three went into service on May 2, 1874, with this second-size Amoskeag double crane-neck engine. The Murray hose wagon replaced the original Amoskeag on July 1, 1895. The chief's Stanley steam automobile probably had just arrived when the original photo for this postcard was taken on Willow Street around 1907. The car was the product of a local factory—the Stanley Motor Carriage Company. Chief of the paid fire department was Walter B. Randlett. *Refs.:* Easterbrook, Horace H. *History of the Fire Department of Newton, Massachusetts.* Boston: 1897. Kimes, Beverly Rae and Henry Austin Clark, Jr. *Standard Catalog of American Cars 1805–1942.* Iola, WI: 1985. Newton city directories: 1899 and 1911. Smith, S. F. *History of Newton.* Boston: 1880.

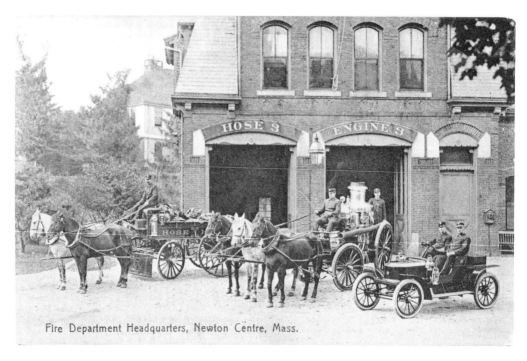

Fire Department Headquarters, Newton Centre, Mass.

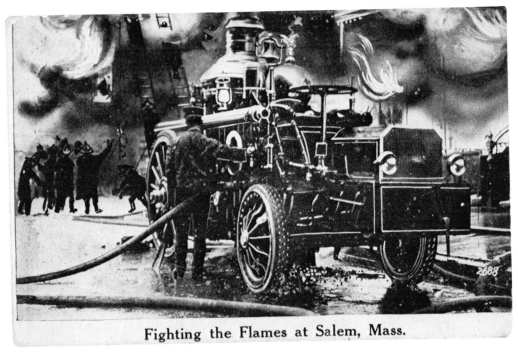

Fighting the Flames at Salem, Mass.

90. SOMERVILLE (AND SALEM), MASSACHUSETTS. The great Salem fire of June 25, 1914, destroyed 1,376 buildings on 253 acres and left 20,000 people homeless. The seven-unit Salem Fire Depart-ment of 97 men was joined by crews and equipment from 22 other departments. Somerville sent an American-LaFrance combination wagon as well as this Ahrens-Fox steam engine drawn by a gasoline engine-powered Christie tractor. The Somerville engine arrived about six hours after the fire started and worked until the water supply gave out four hours later. *Ref.:* Jones, Arthur B. *The Salem Fire.* Boston: 1914.

91.–93. SPRINGFIELD, MASSACHUSETTS. What better way to support a hometown industry than by purchasing locally built fire apparatus? The early Knox vehicles were known for their air-cooled engines, an advantage for equipment that had to operate in very cold weather. The Knox chassis were fitted with fire equipment by the Combination Ladder Company of Providence, Rhode Island.

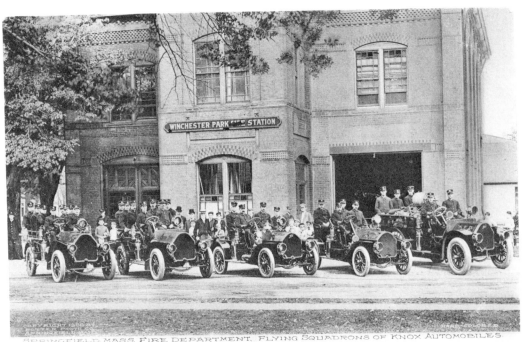

SPRINGFIELD, MASS. FIRE DEPARTMENT, FLYING SQUADRONS OF KNOX AUTOMOBILES

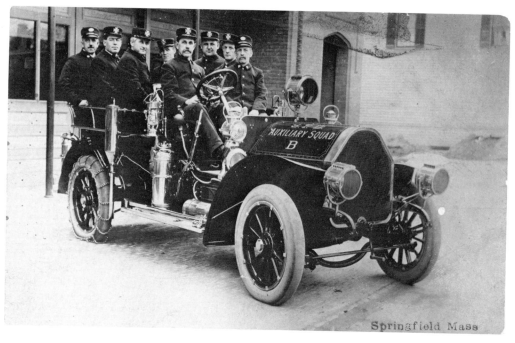

**91.–93.
CONTINUED**

In Springfield, the flying squadrons provided men and chemical extinguishers in rapid response to alarms. The close-up of one of ten cars (Card 92) shows not only a full and well-uniformed crew, but also a comprehensively equipped vehicle. Perhaps most intriguing is the combination of tire chains and sander in front of the rear wheel. Apparently, the sander was operated by a fireman seated behind the driver.

The third Springfield card shows a later stage in the fire department's motorization. In addition to the cars seen in Card 91, Hook and Ladder Number One's Seagrave aerial is shown twice (center of top photo and bottom). We also have a glimpse of Hose Truck Number Three: a Knox fitted with both deck turret and chemical tank. The upper photo was taken in front of the new headquarters building at 86 Court Street.

By 1915, only two steam and two ladder engines remained horse-drawn, and Springfield's fire department horse roster was down to thirteen from 62 five years before. *Refs.*: Loore, Thomas A. *Souvenir History of the Springfield Fire Department.* Springfield: 1912. McCall, Walter P. *American Fire Engines Since 1900.* Glen Ellyn, IL: 1976. Springfield city directories: 1910 and 1915.

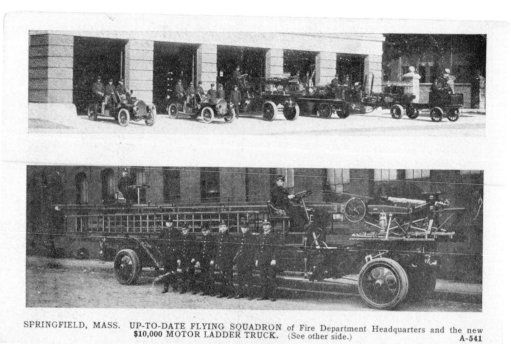

SPRINGFIELD, MASS. UP-TO-DATE FLYING SQUADRON of Fire Department Headquarters and the new $10,000 MOTOR LADDER TRUCK. (See other side.) A-541

94. STOUGHTON, MASSACHUSETTS.

Stoughton's Pope-Hartford combination chemical-and-hose car, circa 1912, had two chemical tanks that (with appropriate coordination among the crew) allowed for a near continuous stream. Electricity was, apparently, confined to engine ignition, so the searchlight was acetylene-fueled, and the siren was hand-cranked. As in many fire depart-

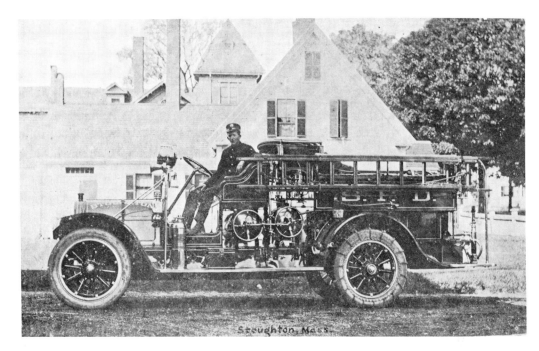

ments, the chains were used year round, improving traction on both muddy and snowy roads.

95. WORCESTER, MASSACHUSETTS.

In 1904, Chief George Coleman's department consisted of seven steamer companies averaging ten men each, four chemical companies averaging four men, five ladder companies averaging eleven men, and ten hose companies averaging eight men. The daily wage was $2.75 for drivers, hosemen, and laddermen. Engineers of the steamer made $2.85 or $3.00 while callmen earned $275 a year. Chief Coleman earned $2,000 per year throughout the 1900's.

The Governor Lincoln Steamer Number One (center left) received an Amoskeag engine in 1873. Worcester also used Silsby and Button engines.

The Insurance Patrol was supported by insurance companies doing business in Worcester. Its eight men strove to protect property from water and fire damage. They carried two Babcock extinguishers, 250 rubber covers, brooms, pails and sponges.

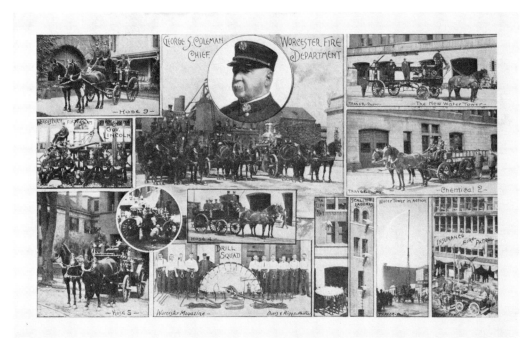

The spring-raised, 65-foot Seagrave water tower arrived in Worcester in 1909. It survives at the Altamont, New York, fairgrounds. *Refs.*: *Amoskeag Steam Fire Engines.* Philadelphia, 1895; rpt. Manchester: 1974. Hass, Bill. *History of the American Towers.* Sunnyvale, CA: 1988. Worcester city directories: 1904, 1906, 1909, and 1910.

96. BAY CITY, MICHIGAN.

The Bay City combination chemical-and-hose wagon was mounted on a circa 1912 Oldsmobile chassis. A decade later, in 1924, chemical tanks were nearly universal on Bay City apparatus. Nine of eleven vehicles, including three engines and two ladder trucks, were fitted with the quick-acting tanks. Shortly thereafter, chemical tanks

Flying Squadron, Bay City, Mich.

became obsolete, replaced by booster lines that did not require chemical recharging.

Refs.: Abriel, Warren W. *The History of the Paid Albany Fire Department*. Albany: 1967 (shows similar 1912 Oldsmobile chassis operated by the Albany Protectives). Bay City city directories: 1909 and 1924.

97. BATTLE CREEK, MICHIGAN.
Camp Custer was established in 1917 as a First World War training base. The Model T Ford on the left, labeled "Q. M. C. U. S. A." for the Quartermaster Corps, apparently had a rear-mounted pump that used the suction hose draped over the hood. The wagon on the right has a load of extinguishers under the ladders, so one wonders where the delivery hose for the Ford's pump was. Perhaps it was on the reel behind the wagon driver, although that might be the hose for the chemical tank below.

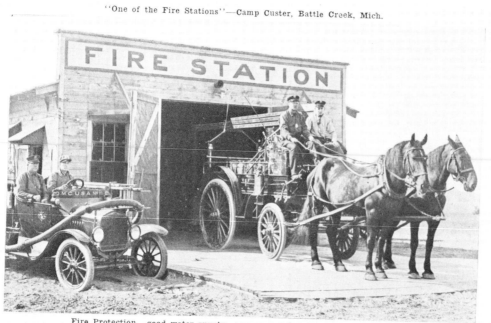

"One of the Fire Stations"—Camp Custer, Battle Creek, Mich.

Fire Protection, good water supply, sewerage and sanitation provided for.

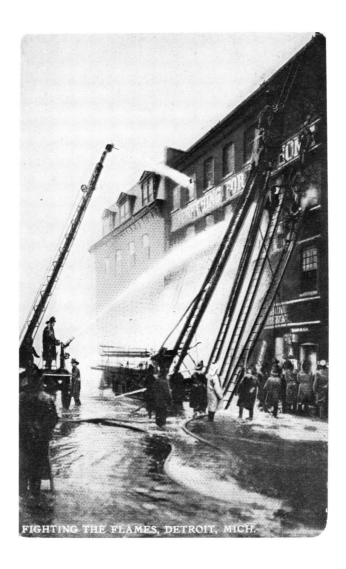

FIGHTING THE FLAMES, DETROIT, MICH.

98. DETROIT, MICHIGAN. Fire suppression at the beginning of the twentieth century was not much like firefighting at the end. The dangers and challenges remain, but the equipment has changed greatly. Displaced with the passing of time were Detroit's 65-foot Champion water tower of 1893, the horse-drawn truck, and the wooden ground ladders leaning against the burning furniture store. *Ref.*: Hass, Bill. *History of the American Water Towers*. Sunnyvale, CA: 1988.

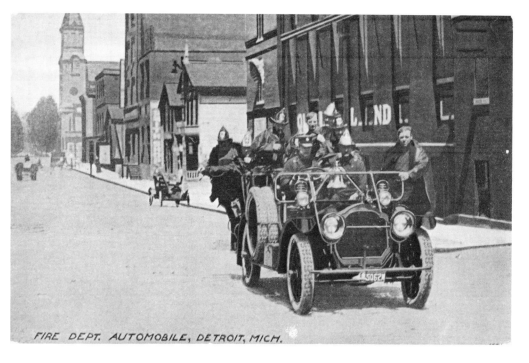

FIRE DEPT. AUTOMOBILE, DETROIT, MICH.

99. DETROIT, MICHIGAN.

This 1911 or 1912 four-cylinder Packard served the Detroit Fire Department as a squad car. The double spare tires attest to the fragile nature of pneumatics in that period. The looping tube above the dashboard provided a handhold for firefighters standing on the running boards—a risky practice. *Ref.*: Kimes, Beverly Rae and Henry Austin Clark, Jr. *Standard Catalog of American Cars 1805-1942*. Iola, WI: 1985.

100. PORT HURON, MICHIGAN. Station Two at 605 Broad Street survived until the late 1950's when it was razed to make way for a civic auditorium. By then, steam engines had long ago given way to motorized apparatus, here a 100-foot American LaFrance aerial of 1955 vintage, an American LaFrance service-ladder truck of 1928, and a

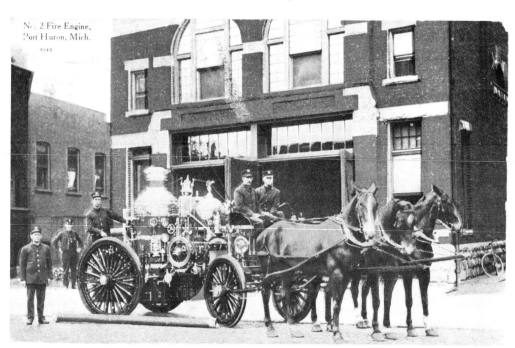

No. 2 Fire Engine, Port Huron, Mich.

reserve, 750-gallon-per-minute American LaFrance pumper of 1928 all shared quarters and used the single apparatus opening at the center of the building. A hose tower on the structure was outside of the photographer's view. *Ref.*: Citizens Research Council of Michigan. *Integration of Police and Fire Services in Port Huron, Michigan*. Detroit: 1957.

101. SPRINGPORT, MICHIGAN.

The apparatus standing in front of the firehouse suggests that this was equipment of a volunteer company operating on a small budget. Perhaps the one new vehicle is the horse-drawn, gasoline engine-powered Waterous engine on the left. Compared to steam engines, the gasoline machine was quick to start and easy to maintain for a fire department without full-time personnel.

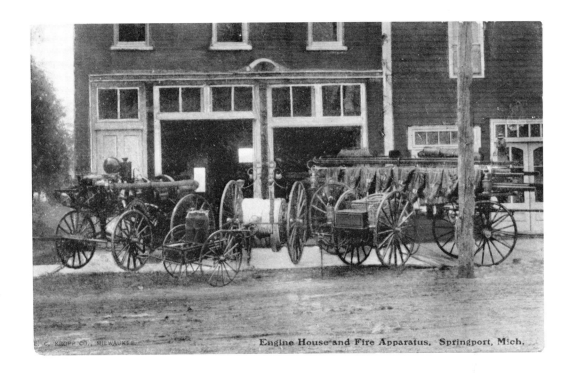

Engine House and Fire Apparatus, Springport, Mich.

The two extinguishers on a handcart were possibly a combination put together by the firemen themselves, rather than by a manufacturer. The hose cart, two-wheel chemical engine, and the ladder truck were also small, simple, but useful apparatus. *Ref.*: Waterous Engine Works Company. *Catalogue.* 1906; rpt. Staten Island, NY: 1974.

102. MANKATO, MINNESOTA.

In 1904, the Mankato Fire Department apparently relied upon pressure in the city's water mains since there were no pumping engines on the equipment roster. This Central Station housed Excelsior Hose Company Number One and Superior Hose Company Number Two as well as Hook and Ladder Company Number One. Drivers were paid, but the remaining personnel were volunteers—the captains of the three companies being, respectively, Milton Hanna, a grocer; Michael L. Fallenstein, a barber; and William A. Funk, an attorney. Chief Alvah D. Beach, a wagon maker, also commanded a chemical company and a second ladder company in two other stations. *Ref.: Mankato City and Blue Earth County Directory, 1904-1905.*

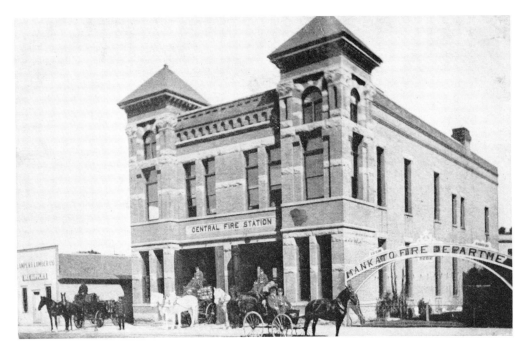

103. JOPLIN, MISSOURI.

Joplin was home to Al C. Webb, founder of the Webb Motor Fire Apparatus Company. The first Webb motor apparatus was the chemical engine built on a Buick chassis seen at the lower right. It was delivered to the Joplin Fire Department in June, 1907. Of the other rigs on the postcard—two hose trucks and a

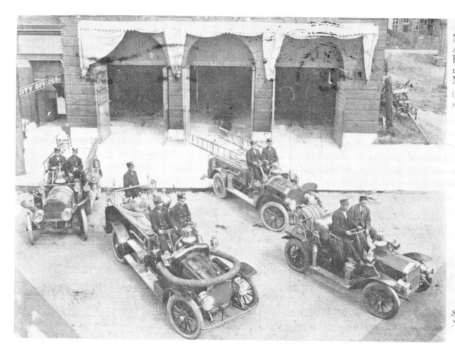

No. 9. Automobile Fire Department, Joplin, Missouri. *(Only one in the U. S.)*

Simon Notion Co.

combination piston-pumper-and-hose-truck—the former, at least, were Webb-built. In spite of the card's label, there may well have been some horses still around when the photo was taken; note the swinging harness inside the right-hand station door. *Ref.*: McCall, Walter P. *American Fire Engines Since 1900*. Glen Ellyn, IL: 1976.

104. KANSAS CITY, MISSOURI.

In April, 1910, the Kansas City Fire Department had eleven steam engines on its roster:

1 Ahrens Continental Extra First-Size (1,100 g.p.m.)
1 Metropolitan Extra First-Size
2 Nott Extra First-Size
1 Silsby Second-Size (700 g.p.m.)

1 Ahrens Third-Size (600 g.p.m.)
2 LaFrance Third-Size
2 Clapp and Jones Third-Size
1 Gould Second-Size (in reserve)

The postcard shows horses being exercised, hitched to one of the engines. Note the lunch car behind the rear wheel. *Ref.*: Poarch, Weldon, ed. *Kansas City Fire Department.* Marceline, MS: 1975(?).

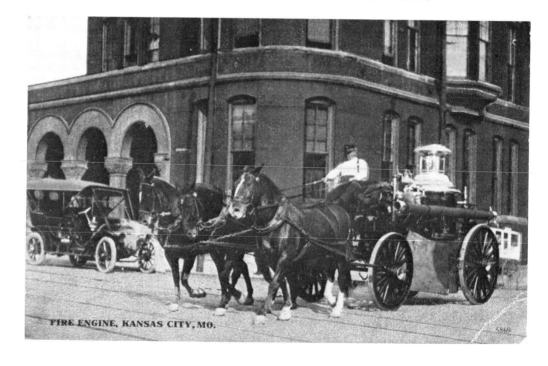

FIRE ENGINE, KANSAS CITY, MO.

105. ST. LOUIS, MISSOURI.

The artist who re-touched this postcard made it more interesting by putting onlookers in the second-story windows. In night-clothes, these people were presumably roused by the engine's gong. Of note, too, is a second

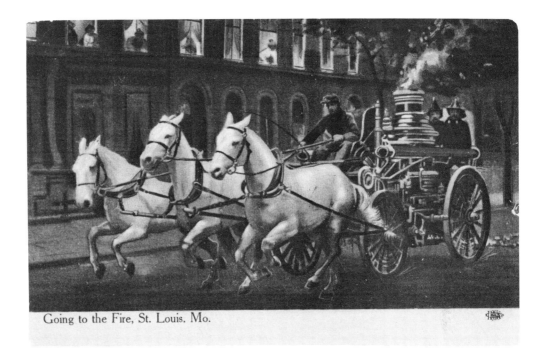

Going to the Fire, St. Louis. Mo.

fireman riding behind the boiler. In 1907, St. Louis had 45 engine companies, 16 ladder companies, and two water tower companies. *Ref.*: St. Louis city directory: 1907.

106. HATTIESBURG, MISSISSIPPI. This pristine combination chemical-and-hose wagon was also equipped with long ground ladders. The uniforms with campaign hats were unlike any others in this postcard collection.

By 1923, Hatties-burg had three paid fire companies. Number One was stationed at the headquarters at City Hall; the Chief was Charles E. Norsworthy. *Ref.*: Hattiesburg city directory: 1923.

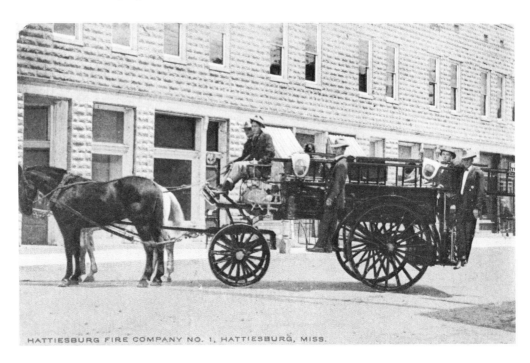

HATTIESBURG FIRE COMPANY NO. 1, HATTIESBURG, MISS.

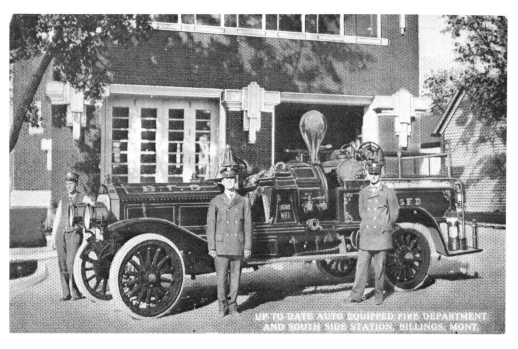

107. BILLINGS, MONTANA.

The Robinson Fire Apparatus Company of St. Louis, Missouri, built Billings' combination piston pumper, chemical-engine-and-hose truck about 1911. With the exception of the Ahrens-Fox firm, relatively few piston pumps were fitted to motor apparatus by other manufacturers. Billings Station One was at the rear of City Hall. Station Two was at 201 South Thirtieth Street. Alarms were sounded by rapidly ringing the City Hall bell five times. *Refs.*: Billings city directory: 1919. McCall, Walter P. *American Fire Engines Since 1900.* Glen Ellyn, IL: 1976.

108. BEATRICE, NEBRASKA. On Memorial Day, 1916, Beatrice was an inviting community. Prominent in the parade was the fire department's White Motor Company chemical engine built in Cleveland, Ohio. The horse-drawn hose wagon was decorated similarly with American flags. *Ref.*: McCall, Walter P. *American Fire Engines Since 1900.* Glen Ellyn, IL: 1976.

109. CONCORD, NEW HAMPSHIRE.

Concord's Central Fire Station was erected on Warren Street in 1875 at a cost of $30,000. The 62-foot by 52-foot main structure was abutted by a 57-foot by 36-foot barn, which, in turn, was attached to a 26-foot by 46-foot shed. All of these buildings were built of brick.

In 1888, the tower was rebuilt in the taller configuration seen here. Although no steamers appear

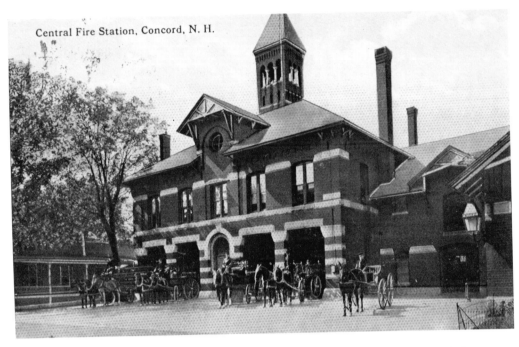

Central Fire Station, Concord, N. H.

in this postcard, four were on the equipment roster in 1897; there were five engine companies in 1910. *Refs.:* Concord city directories: 1897 and 1910. Lyford, James O., ed. *History of Concord.* Concord: 1903.

110. CONCORD, NEW HAMPSHIRE. This Robinson Fire Apparatus Manufacturing Company combination chemical engine arrived at Concord's headquarters building about 1910. The two tanks delivered pressurized water through

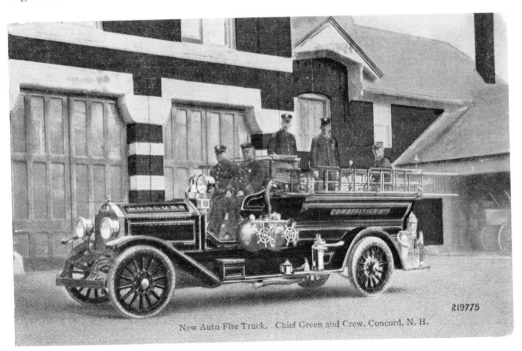

the hose coiled behind the seat. Note the drive chain, visible just in front of the left rear wheel.

"Chief Green" was William C. Green, who lived next door to the Central Fire Station on Warren Street. *Ref.:* Concord city directory: 1910.

New Auto Fire Truck. Chief Green and Crew, Concord, N. H.

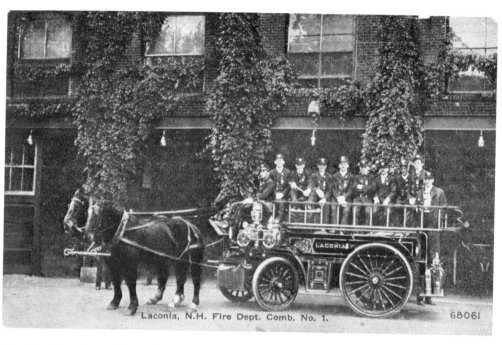

Laconia, N.H. Fire Dept. Comb. No. 1. 68061

111. LACONIA, NEW HAMPSHIRE.

This chemical-and-hose combination was a twentieth century addition to the Laconia Fire Department. In the 1890's, the roster was comprised of an engine, two ladder trucks, and six hose wagons. An adequate water supply was assured by 106 hydrants and thirteen reservoirs. The fire alarm telegraph was supplemented with gongs and a steam whistle. *Ref.*: Vaughan, Charles W. *The Illustrated Laconian.* Laconia: 1899.

112. MANCHESTER, NEW HAMPSHIRE. Could this be anything but an Amoskeag engine in the city where Amoskeags were built? Certainly not, for N. S. Bean Steamer Number Four operated a first-size Amoskeag with register number 692 that was delivered in March, 1893. It replaced an Amoskeag of 1867 vintage. In fact, four engine companies in Manchester each had two generations of Amoskeags while a fifth company joined the fire department in 1888 with an Amoskeag of its own.

Box 17 was at Amherst and Beech Streets. *Refs.: Amoskeag Steam Fire Engines.* Philadelphia, 1895; rpt. Manchester: 1974. Manchester city directory: 1912.

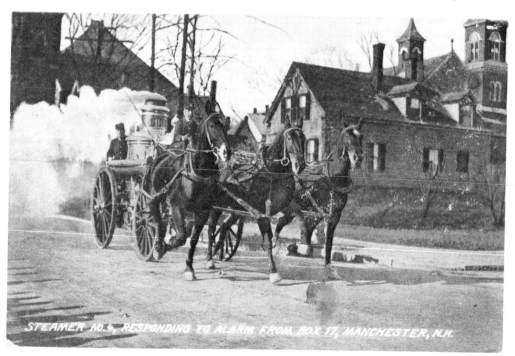

STEAMER NO. 4, RESPONDING TO ALARM FROM BOX 17, MANCHESTER, N.H.

113. NASHUA, NEW HAMPSHIRE.

This imposing Central Fire Station with its bell tower dated from 1870; at the turn of the century, three other substantial fire-houses also served Nashua (see next card). By that time, 24 men and 20 horses operated four steam engines, four hose carriages, two hook-and-ladder trucks, and two chemical engines. For this postcard scene, a fire depart-

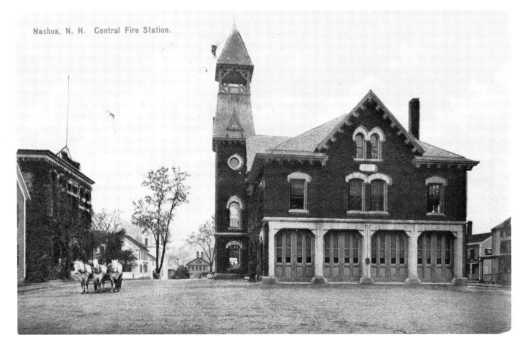

ment vehicle drawn by a three-horse hitch passed by some early nineteenth century residences as it headed for the camera. *Refs.*: Parker, Edward E. *History of the City of Nashua*. Nashua: 1897. *Semi-Centennial Report*. Nashua: 1903.

114. NASHUA, NEW HAMPSHIRE. In the wealth of postcards depicting fire apparatus, this portrait of a hook-and-ladder company provides a striking contrast to the usual scene. Yet, the pride of these volunteers (note their neck-ties under the turn-out coats) was as strong as any in those companies posed with an engine or truck. An observer in the 1890's noted that the Nashua department had always "maintained a good name for efficiency and [has] been officered and manned by the best citizens." Since 1891, the fire department had been "out of politics" through

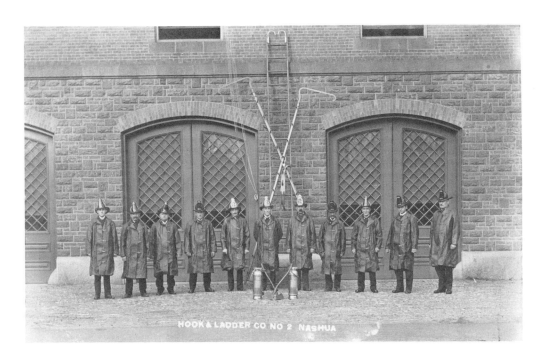

supervision by a commission elected by the city council.

Note the tools of the hook-and-ladder company: the ground ladder, the scaling ladders (pompier type), the extinguishers, the axes, and the lifebelt used on ladders. The two-story firehouse had a four-story tower (on the left outside the scope of the original photo). *Ref.*: Parker, Edward E. *History of the City of Nashua*. Nashua: 1897.

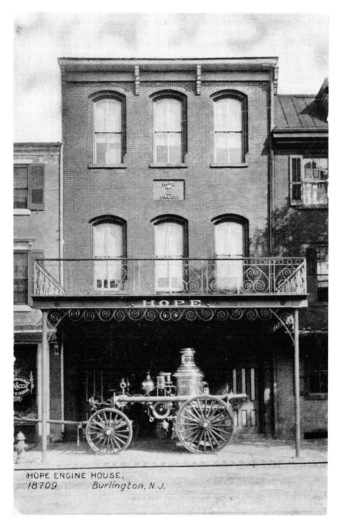

HOPE ENGINE HOUSE,
18709 *Burlington, N. J.*

115. BURLINGTON, NEW JERSEY.

The Washington and Hope Hose Company, organized in 1849, had a Patrick Lyons hand engine as its first apparatus. In 1869, the house shown here was erected on High Street north of Pearl.

In 1871, a second-hand Amoskeag steamer was acquired from a fire company in Philadelphia, becoming the first steam engine in Burlington. And in 1872, the company was renamed Hope Steam Engine.

Motorization came in 1924 with a triple combination rig that carried a 900-gallon-per-minute piston pump, a 40-gallon chemical tank, and 1,200 feet of 2½-inch hose. *Ref.*: Schermerhorn, William E. *The History of Burlington, New Jersey.* Burlington: 1927.

116. DOVER, NEW JERSEY. May and Blossom hauled the truck of Protection Hook and Ladder Company Number One. In the 1900's, when this photo probably was made, the ladder and two engine companies comprised Dover's volunteer department.

Organized in 1873 when the Dover men had a Harrel and Hayes steam engine, the company purchased a ladder truck the next year. A Clapp and Jones followed in 1885 and a municipal water system in 1887 to augment fire suppression.

In 1922, when Protection had replaced the horses with a Mack truck, 200 hydrants varying in pressure from 176 pounds at the low point to 40 pounds at the high point served the fire department. *Refs.*: Platt, Charles D. *Dover Dates.* Dover: 1922. *Richmond's Morris County Directory, 1908–1909.*

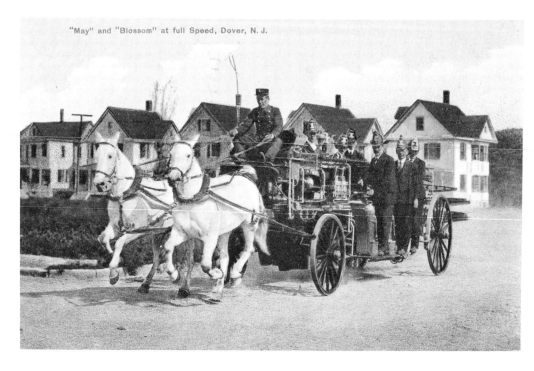

"May" and "Blossom" at full Speed, Dover, N. J.

117. ELIZABETH, NEW JERSEY.

In 1907, the assistant chief of the paid Elizabeth Fire Department was William J. Mahoney. Engine Number Five at 131 Magnolia Avenue was directed by Captain Dennis J. Sullivan, who may be posed at the left in this postcard. In all, the department ran six engines and two ladder trucks.

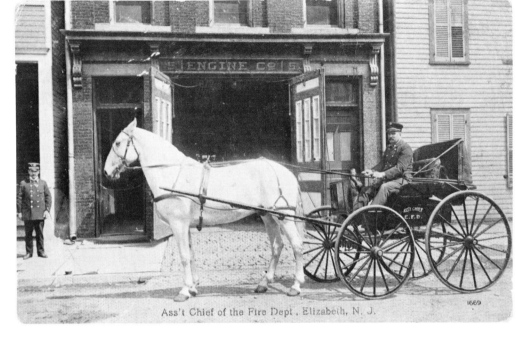

Ass't Chief of the Fire Dept, Elizabeth, N. J.

In 1888, the volunteer Elizabeth department had William Mahoney as chief engineer; perhaps these two Mahoneys were the same man. *Refs.*: Elizabeth city directories: 1888, 1907, and 1911.

118.–119. ELIZABETH, NEW JERSEY. In 1911, August Gerstung was chief of the Elizabeth Fire Department. Hook and Ladder Number One at 28 South Broad Street had Robert Bauermann as captain and Paul C. Zellmer as tiller-man. Red Jacket Number Four received a third-size Amoskeag engine in August, 1890. The steamer operated from quarters at 147 Elizabeth Avenue in 1911 with Fred Clark as captain and Harris Fine as engineer. *Refs.*: *Amoskeag Steam Fire Engines.* Philadelphia, 1895; rpt. Manchester: 1974. Elizabeth city directories: 1911 and 1913.

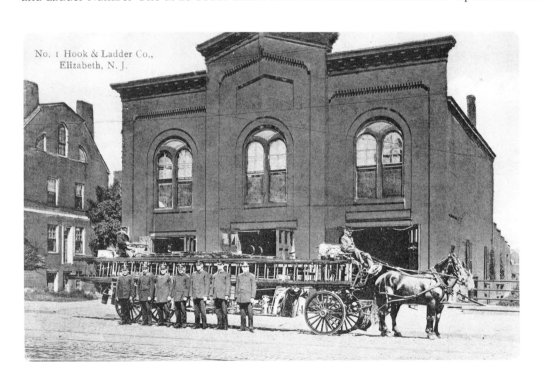

No. 1 Hook & Ladder Co., Elizabeth, N. J.

119.

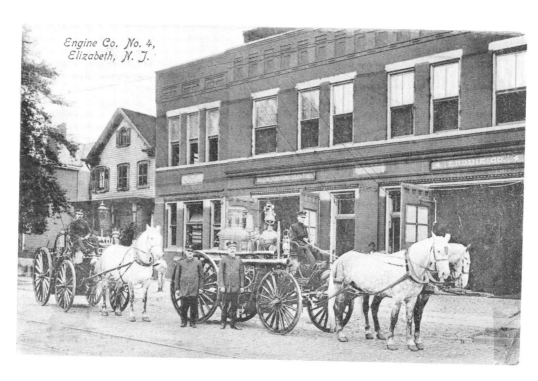

Engine Co. No. 4,
Elizabeth, N. J.

120. ELIZABETH, NEW JERSEY. Truck Number Three operated this 1912 American-LaFrance Type 16 aerial with its 65-foot ladder. A four-cylinder gasoline engine powered a generator which, in turn, ran two electric motors at the front wheels. Ground ladders carried on the sides of the truck supplemented the aerial.

In 1913, the captain of Truck Three was Robert Bauermann and tillerman was Paul C. Zellmer, both of whom were assigned to the horse-drawn Hook and Ladder Number One two years before.

Truck Three was at High and Park Streets and could be reached at telephone number 2168. *Refs.*: Elizabeth city directories: 1911 and 1913.

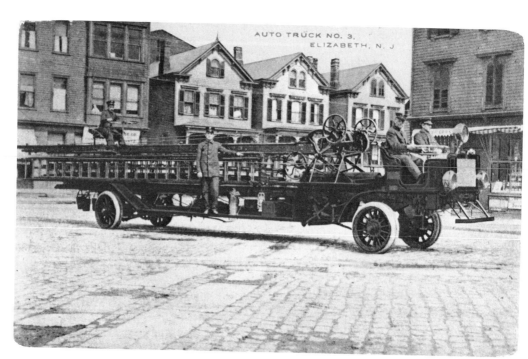

AUTO TRUCK NO. 3,
ELIZABETH, N. J

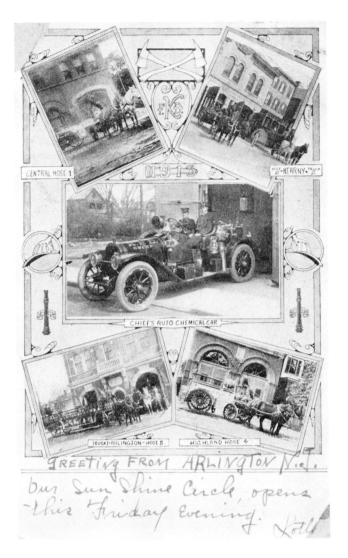

121. KEARNY, NEW JERSEY. Although the greetings are from Arlington, these postcards show the apparatus of the Kearny Fire Department. Sitting in the car is Chief Charles W. Greenfield, who served from before 1907 until at least 1920. In 1913, Central Hose Number One under Captain William Swiss was at Davis and Tappan Streets. Kearny Hose Number Two (Captain James Durkin) shared quarters on Kearny Avenue with Truck Two (Francis Downey). Similarly, Arlington Hose Number Three (William Breeze) and Truck Number One (James Hall) were together at the corner of Midland and Kearney Avenues. Highland Hose (Fred Otto) was on Halstead Street.

Three fire commissioners supervised the operation of the department. The firemen were volunteers, many of them tradesmen. Machinists, tool makers, and carpenters were active as officers. *Refs.*: Harrison, Kearny, East Newark, and Arlington city directories: 1907, 1911, 1913, and 1915.

122. LAMBERTVILLE, NEW JERSEY. Lambertville's model A-C Ahrens-Fox was shipped from the Cincinnati, Ohio, factory on June 21, 1913. A six-cylinder, 1,015-cubic-inch, 80-horsepower engine powered the rear wheels with their hard rubber tires as well as the two-cylinder, 700-gallon-per-minute pump at the front of the chassis. Note also the large chemical tank behind the seat. This vehicle was discarded in 1945. *Ref.*: Hass, Ed. *Ahrens-Fox, The Rolls Royce of Fire Engines.* Sunnyvale, CA: 1982.

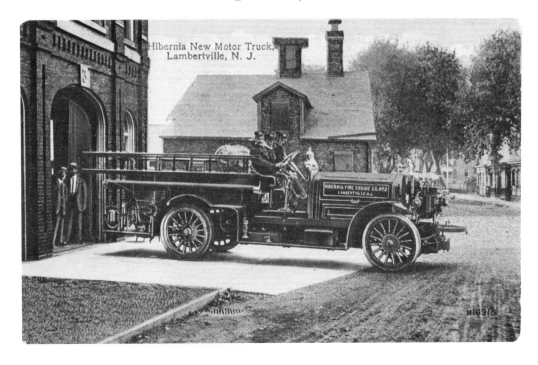

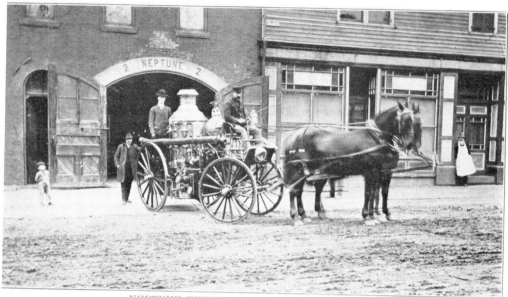

NEPTUNE ENGINE. No. 2, NEW BRUNSWICK. N. J.
Pub. by Hammell Bros., New Brunswick, N. J.

123. NEW BRUNSWICK, NEW JERSEY.

Neptune Engine Company Number Two was organized in 1796. A hand engine gave way to a Jeffers steamer, which, in turn, made way for this LaFrance. It saw initial service at the First Presbyterian Church fire of September 18, 1888. In 1914, a Cross motor tractor replaced the horses, and a paid department displaced the New Brunswick volunteers. *Ref.:* Wall, John P. *The Chronicles of New Brunswick, New Jersey.* New Brunswick: 1931.

124.–127. NEWARK, NEW JERSEY. These four postcards depict the variety of apparatus operated in the 1910 period by the Newark Fire Department. In 1911, there were 22 steamers on the roster. Number Eighteen, under Captain Patrick J. Donahue, ran from a fire house at Eighteenth Avenue and South Twelfth Street.

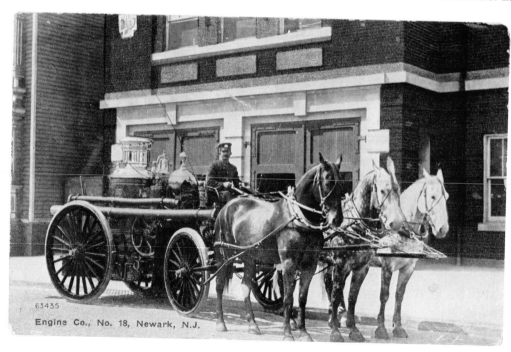

63435
Engine Co., No. 18, Newark, N.J.

125.

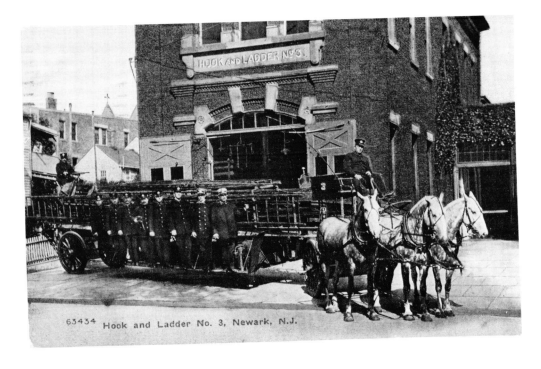

63434 Hook and Ladder No. 3, Newark, N.J.

124.–127. CONTINUED

Ladder Three, directed by Captain James A. Johnston at 84 Bruce Street, was one of eight trucks. Two singular units were the chemical engine and the 1903, 65-foot Champion water tower. In 1916, they were housed together at 56 Prospect Street. In the action postcard, the

126.

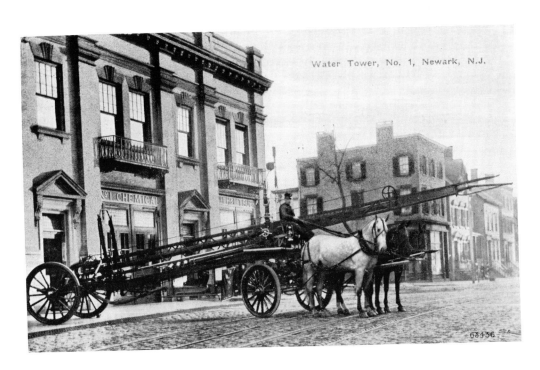

Water Tower, No. 1, Newark, N.J.

63436

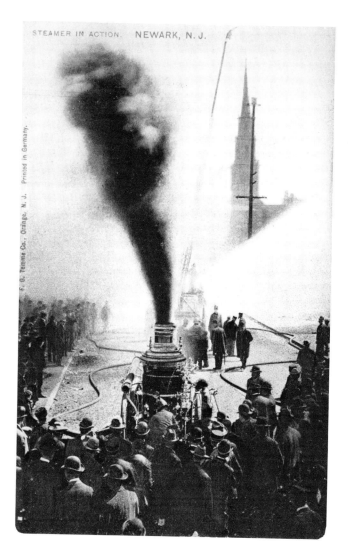

124.–127. CONTINUED

water tower with one deck gun in operation can be seen behind the engine. The tower, motorized in 1918, survived until destroyed in a 1935 accident. *Refs.*: Hass, Bill. *History of the American Water Towers.* Sunnyvale, CA: 1988. Newark city directories: 1906, 1911, and 1916. Urquhart, Frank. *Short History of Newark.* Newark: 1908.

128. PATERSON, NEW JERSEY. Paterson motorized Truck Two with a Christie tractor. This postcard shows the remodeled rig in front of fire headquarters, which also housed Engine Five. Built by the Front Drive Motor Company of Hoboken, the four-cylinder Christies replaced horses at the front of many steam engines as well as ladders. *Refs.*: McCall, Walter P. *American Fire Engines Since 1900.* Glen Ellyn, IL: 1976.

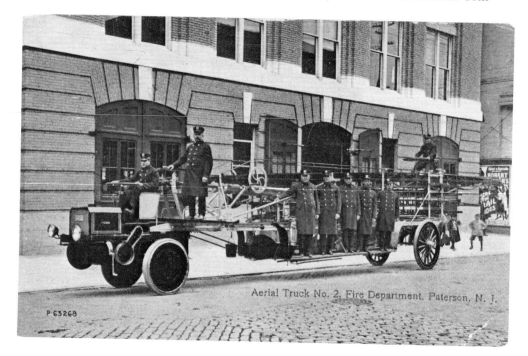

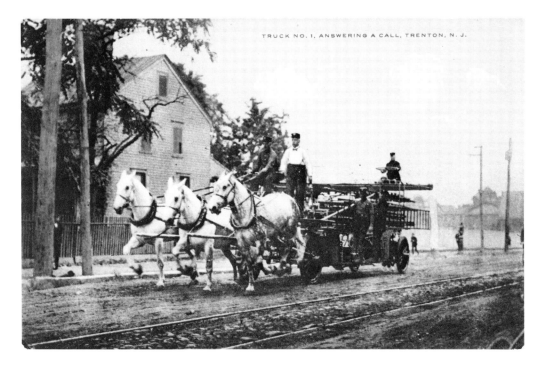

TRUCK NO. 1, ANSWERING A CALL, TRENTON, N. J.

129. TRENTON, NEW JERSEY. Trenton switched to a paid fire department in 1892 when there were nine engine, eleven hose, and two truck companies. In 1908, Truck Company Number One was at 53 and 57 Hanover Street. We can marvel at the officer seen here standing on the apparatus behind three galloping horses. At that time, Captain was Charles A. Knoblauch, Lieutenant was Alexander Grugan, and Driver was Angus McDougall. Six laddermen were assigned to the company. Ten years later, the department completed motorization of its 27 vehicles. *Refs.*: Lee, Francis B. *History of Trenton, New Jersey.* Trenton: 1895. Trenton city directories: 1908, 1910, 1913. Walker, Edwin R., et al. *A History of Trenton, 1679–1929.* Princeton: 1929.

130. UNION HILL, NEW JERSEY. The American-LaFrance Fire Engine Company of Elmira, New York, delivered this Type 16 aerial to Union Hill in 1913. It carried a 65-foot ladder while other versions of this truck were built with 75- and 85-foot ladders. One of the electric motors that drove the front wheels is visible just inside the hub at the front corner of the truck. Out of sight are the seat and tiller for the steerable rear wheels. But also notable here is an early installation of electric lights. *Refs.*: American-LaFrance Fire Engine Company, Inc. *Sales List to May 31, 1927.* McCall, Walter P. *American Fire Engines Since 1900.* Glen Ellyn, IL: 1976.

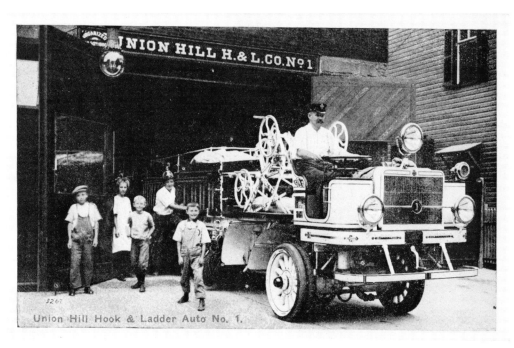

Union Hill Hook & Ladder Auto No. 1.

131. DEMING, NEW MEXICO.

This 1914, six-cylinder Type 12 American-LaFrance provided comprehensive fire protection for Deming. Under the seat was a 1,000 -gallon-per-minute rotary pump. Behind it was a chemical tank with its hose in the rack above. In the bed was the delivery hose for the pump. With a ground ladder on the right side and smaller items (such as the extinguisher),

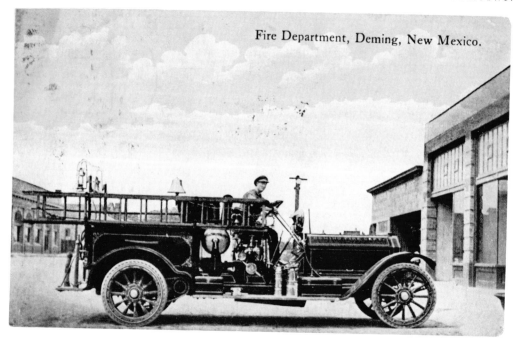

this rig was fully equipped. Note the hard rubber tires that provided a firm but puncture-proof ride. In 1918, Deming added a Type 40 combination engine with a smaller, Junior pump. *Refs.*: American-LaFrance Fire Engine Company, Inc. *Sales List to May 31, 1927.* McCall, Walter P. *American Fire Engines Since 1900.* Glen Ellyn, IL: 1976.

132. AUBURN, NEW YORK. The Auburn Fire Department put this Knox combination chemical- and-hose wagon into service in June, 1911. During the 1910's the department was organized into six hose and one ladder companies, apparently relying on the pressure in the water mains to substitute for engine companies. This system had contin-

ued for a quarter of a century; a survey in 1886 disclosed that Auburn had six hose carts, 8,000 feet of hose, two hook-and-ladder trucks, a patrol wagon, 29 alarm boxes, and 430 hydrants for fire protection. *Refs.*: Allen, Henry M. *Chronicle of Early Auburn.* Auburn(?): 1953. Auburn city directory: 1916. Sanborn insurance map: 1886.

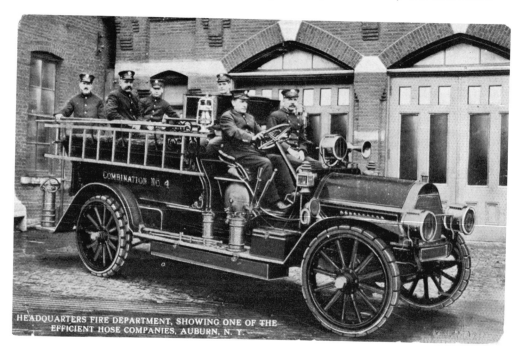

BINGHAMTON, N. Y., CENTRAL FIRE STATION.

133.
BINGHAMTON, NEW YORK.

The Binghamton Fire Department in 1898 had 533 men, seventeen of whom were fully or partially paid. Seventeen men and fifteen horses were always on duty.

Equipment included third-size Silsby and third-size LaFrance steam engines, a chemical engine, two hook-and-ladder trucks, seven hose carts, and two supply wagons. On hand were 7,200 feet of rubber-lined cotton hose. The firemen could work with 625 hydrants in responding to an alarm system of 42 boxes.

The hose companies had distinctive names, including Crystal, Mechanics', and Rockbottom. By 1911, with one more steamer and one fewer ladder, three of Binghamton's eleven companies had paid crews. *Refs.*: Binghamton city directories: 1900, 1904, 1906, and 1911. Sanborn insurance map: 1898.

134. BUFFALO, NEW YORK. The paid department of New York's second largest city in 1906 was governed by a three-man board of fire commissioners. Fire Chief since 1892 was Bernard T. Connell. Equipment included 31 steam engines (among them were three fire boats), 29 hose wagons (four with chemical equipment), six chemical engines, one water tower, and nine hook-and-ladder trucks (several of them were aerials) with a tenth on order. Another engine was also on its way to join a roster that included Amoskeags, Silsbys, and a Button; most engines were first-

ARRIVAL OF FIRE DEPT. AT FIRE ON GENESEE ST. BUFFALO, N. Y.

size machines. In addition, the department roster had three engines, two ladders, and a chemical engine in reserve. On hand to pull the apparatus were 250 horses. *Refs.*: Amoskeag, Silsby, and Button delivery lists. Endres, Matthias. *History of the Volunteer Fire Department of Buffalo, NY* Buffalo: 1906. Sanborn insurance map: 1889.

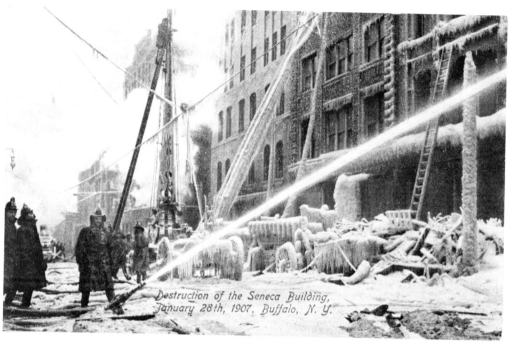

Destruction of the Seneca Building,
January 28th, 1907, Buffalo, N. Y.

135. BUFFALO, NEW YORK.

After a falling wall killed three firemen and injured ten others, the *Buffalo Courier* called this the worst fire in fifteen years. Truck Number Two and the water tower seen here encased in ice were joined by 22 engines and eight other trucks in fighting the $500,000 blaze. The 55-foot Hale tower of 1889 vintage survived in the Buffalo Fire Department until 1951. *Refs.: Buffalo Courier.* January 29, 1907. Hass, Bill. *History of the American Water Towers* Sunnyvale, CA: 1988.

136. COHOES, NEW YORK. This American-LaFrance Metropolitan-style engine represents one of the final evolutions in steamers; its successor was the motor engine. The compact, but powerful, Metropolitan had two steam cylinders mounted above two pump cylinders. A Fox-type return flue boiler provided the steam.

The Murphy engine was one of four steamers run by Cohoes volunteers. In 1911, George Waters, Jr., a planer, was foreman. His predecessors included George Claffey in 1908 and George A. Wickham, a carpet cleaner, in 1904. *Refs.:* Cohoes city directories: 1904, 1908, and 1911.

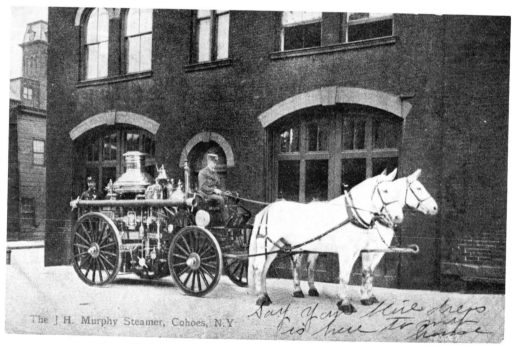

The J H. Murphy Steamer, Cohoes, N.Y.

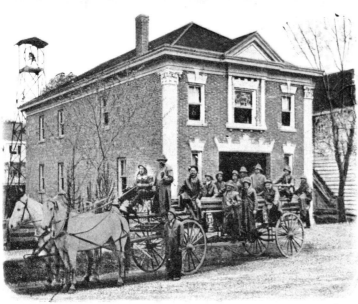

Storm King Engine Co., No. 2. Cornwall on Hudson, N.Y.

137. CORNWALL-ON-HUDSON, NEW YORK.

Here was an engine company with a hook-and-ladder truck. Storm King, organized in 1870, began its firefighting with a hand engine, supplemented later with a hose cart. Perhaps a gravity-fed municipal water system resulted in the addition of a ladder truck instead of more engines. In any event, by 1911, the volunteer Cornwall-On-Hudson department had sixty members; a hand engine; a four-wheel, hand-drawn hose cart; and the hook-and-ladder powered by two horses from a nearby livery stable. Note the bell tower behind the fire house. *Refs.*: Beach, Lewis. *Town of Cornwall.* Newburgh, NY: 1870. Sanborn insurance maps: 1900, 1905, and 1911.

138. CORTLAND, NEW YORK. The Dutch architecture of Cortland's Central Fire Station in 1915 housed a city service motor truck and two combination chemical-and-hose trucks. In addition, the fire department had four two-

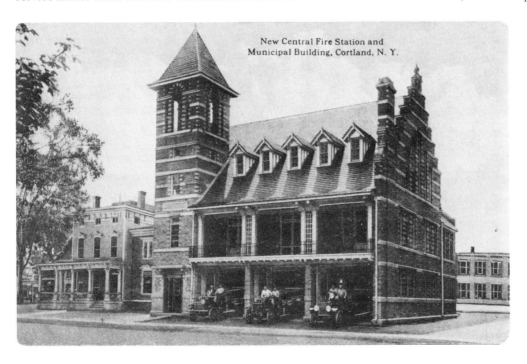

New Central Fire Station and Municipal Building, Cortland, N. Y.

wheel hose carts, six Babcock extinguishers, and a third-size Silsby steam engine. With such little pumping capacity, it is apparent that the city of 13,000 people relied upon water main pressure to fill the department's hoses.

There were four paid men and 165 volunteer firemen in 1915. Twelve men slept in the central quarters for quicker response to alarms. *Ref.*: Sanborn insurance map: 1915.

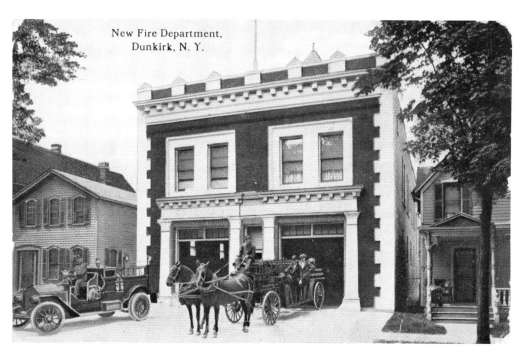

New Fire Department,
Dunkirk, N. Y.

139. DUNKIRK, NEW YORK.

In the 1910's, the Dunkirk Fire Department head-quarters housed the 1912, Type 10 American LaFrance combination chemical-and-hose car with a 35-gallon tank (left), the horse-drawn hook-and-ladder (center), and a horse-drawn combination chemical-and-hose wagon with two chemical tanks (not shown). In addition, there were two other stations with apparatus. Five volunteer companies worked with eight to ten paid men who staffed the buildings day and night. By 1919, the apparatus rolled over pavement on twenty miles of Dunkirk's fifty-mile street system. *Refs.*: American-LaFrance Fire Engine Company, Inc. *Sales List to May 31, 1927*. Elmira: 1927. Sanborn insurance maps: 1910 and 1919.

140. ELMIRA, NEW YORK. In 1903, the Elmira Fire Department operated with 42 men and twenty horses. The equipment included three locally built LaFrance engines as well as two Amoskeag steamers; one of the engines is posed on the left of this scene at the East Market Street headquarters. Other vehicles were a Rumsey chemical truck with a 45-foot extension ground ladder, a Hayes truck with a 65-foot ladder (probably the vehicle on the right of the picture), an ordinary hose wagon, and three combination hose wagons. Also available for firefighting were 88,000 feet of 2½-inch hose. *Ref.*: Sanborn insurance map: 1903.

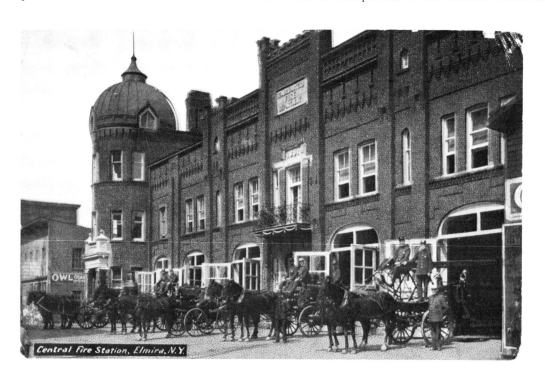

Central Fire Station, Elmira, N.Y.

141. ELMIRA, NEW YORK.

The American-LaFrance name was formed in 1903 from elements in the names of the American Fire Engine Company of Seneca Falls, New York, and the LaFrance Fire Engine Company of Elmira. The new company succeeded a short-lived International Fire Engine Company, which had joined many of the old, established fire apparatus

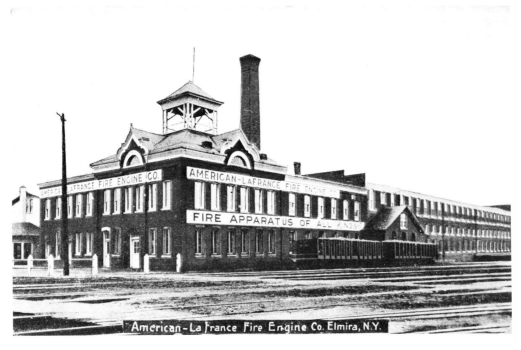

American-La France Fire Engine Co. Elmira, N.Y.

manufacturers in a grand scheme to create a fire engine trust in 1900. The American-LaFrance Company consolidated apparatus production at Elmira, where operations remained until 1985. *Ref.*: American-LaFrance. *First Water.* Elmira: 1972.

142. GENEVA, NEW YORK. Named for Judge Charles Folger, this hook-and-ladder company was organized on February 19, 1886, and received its truck on the following April 21. Quarters were here on Seneca Street, where a new American-LaFrance truck was housed in 1910. The truck's weight was a factor in the move in 1912 to a new house behind City Hall. Later, a Christie gasoline tractor replaced the team of horses. Eventually, a Seagrave motor hook-and-ladder truck displaced the horse-era equipment entirely. *Refs.*: Emmons, E. Thayles. *The Story of Geneva.* Geneva: 1931. Munroe, John H. *A Century and a Quarter of History.* Geneva: 1912.

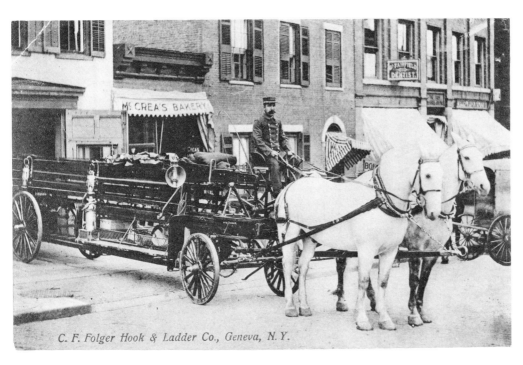

C. F. Folger Hook & Ladder Co., Geneva, N.Y.

GLOVERSVILLE, N. Y. CITY HALL.

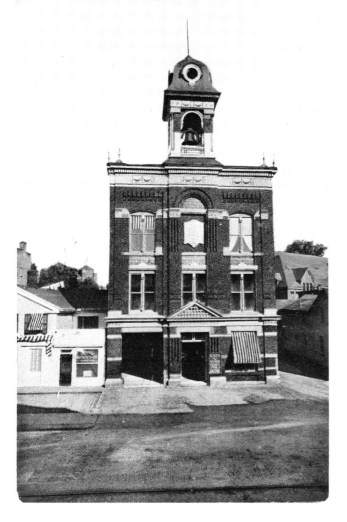

143. GLOVERSVILLE, NEW YORK. In 1911, the Gloversville Fire Department had three stations, including City Hall at 48 North Main Street. Long-time Chief Reuben A. Maxson had both full-time paid and call men in his command. They operated a hose wagon, two combination hose-and-chemical wagons with forty-gallon tanks, and a hook-and-ladder truck. The fire bell signals were:

> 1 stroke = wire broke
> 3 strokes = fire out
> 4 strokes = fire drill
> 5 strokes = trial of boxes
> 4-4-4 strokes = general alarm (probably three groups of four bells)
> 1-1-1 strokes = high pressure (probably a call for high pressure)

Refs.: Gloversville city directories: 1902, 1907, 1910, and 1911. Sanborn insurance maps: 1902, 1908, and 1912.

144.

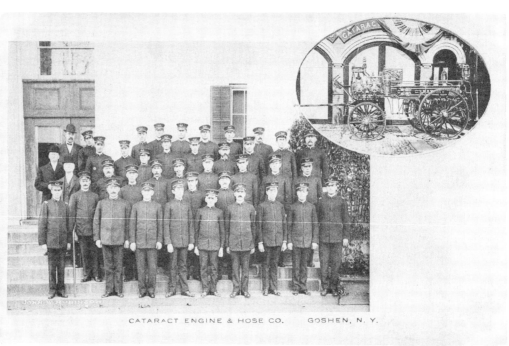

CATARACT ENGINE & HOSE CO. GOSHEN, N. Y.

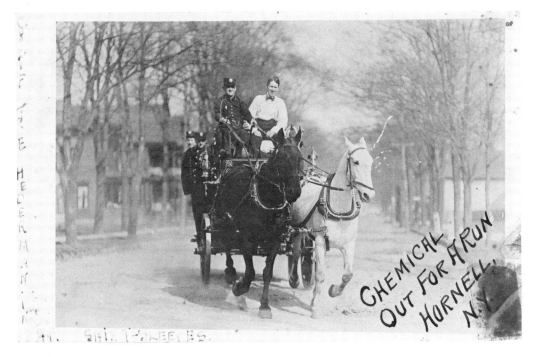

145. HORNELL, NEW YORK.
Chief Joseph Hederman, seen here enjoying a run on Hornell's combination chemical-and-hose wagon, guided a department of seven paid men, ten call men, two volunteer hose companies, and five horses in 1909. In addition to this wagon, Hornell operated a hook-and-ladder truck. A steam engine on the roster in 1904 probably had given way to the combination.

As a railroad town in 1915, Hornell could count on the Erie Railroad's 150-man fire department for a general alarm. *Refs.*: Hornell city directories: 1909 and 1911. Sanborn insurance maps: 1904, 1909, and 1915.

144. GOSHEN, NEW YORK. (Opposite) Goshen's first fire organization, Cataract, was founded in 1843 as an engine company. A merger with a hose company produced the name seen on this card. In 1910, there was still an active hand engine in Goshen, but the pride of the department was probably the Rex Extinguisher Company combination wagon shown at the upper right of this postcard. This apparatus carried two 25-gallon chemical tanks, 100 feet of small diameter hose, 800 feet of 2½-inch hose, and two extinguishers. The volunteer Cataracts included a number of professional men; foreman in 1913 was Percy V. D. Gott, a lawyer. Their long-term president in the late 1890's and early 1900's was William H. Wyker, also a lawyer. *Refs.*: Goshen city directories: 1899, 1903, and 1913. Sanborn insurance maps: 1885, 1889, 1894, 1900, 1905, and 1910. Seese, Mildred P., ed. *Goshen: The Spirit of '64.* Goshen: 1964.

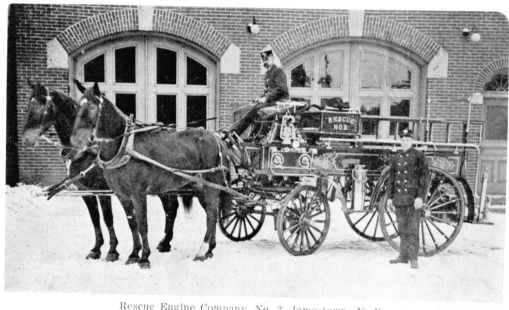

Rescue Engine Company, No. 2, Jamestown, N. Y.

146. JAMESTOWN, NEW YORK. In the late 1880's, Jamestown installed a pressurized water system that allowed the volunteer fire department to retire its hand engines. Then, after a decade of relying entirely on hoses charged by the hydrants, Jamestown acquired by 1904 a LaFrance steamer and two chemical engines (including Rescue Number Two's).

Rescue's thirty members were called out by four strokes on the city's tower bell. In 1903, Driver Frank A. Anderson was a paid fire department employee. Other Rescue personnel remained volunteers, including Foreman Edward D. Bootey, a harness maker, and President Arthur Poole, a warp dresser. *Refs.*: Downs, John P. *History of Chatauqua County.* Boston: 1921. *Centennial History of Chatauqua County.* Jamestown: 1904. Jamestown city directories: 1902 and 1913. Sanborn insurance map: 1891.

THE DUFFEE FIRE, JAMESTOWN, N. Y. *Feb. 17, 1909.* MONROE.

147. JAMESTOWN, NEW YORK. From a report in the *Jamestown Evening Journal:*
The members of the Pearl City Advancement Circle were deep in a game of progressive pedro in the Ellicott lodge, I. O. O. F., when they were startled by the appearance of heavy smoke and the sound of the fire alarm. Without waiting to gather up the cards, they made a rush for the fire escape. . . . Several of the ladies almost fainted, but the majority were quite cool. The fire began in the cellar of Edward Duffee's dry goods store when an employee attempted to light a gas lamp. The head of the match broke off and ignited a bale of cotton batting. Thanks to the fire escapes and ladders from the Ellicott Hook and Ladder Company (seen here), all occupants of the Gokey Building, including many students of the Jamestown Business College, were rescued. And while the steam engine could not get to the scene because of road conditions, the city's water system enabled the firemen to confine damage to the cellar and first floor of Duffee's establishment. *Refs.:* Downs, James P. *Centennial History of Chatauqua County.* Jamestown: 1904. Jamestown city directories: 1903 and 1913. *Jamestown Evening Journal.* February 17 and 18, 1909.

148. LAKE PLACID, NEW YORK. A membership resort, the Lake Placid Club in New York's Adirondack Mountains was founded in 1895. Fire was a major concern, resulting in the establishment of a well-equipped fire department manned by club employees, who, by 1914, competed in firefighting efficiency contests for $360 in cash prizes annually. The monthly drills, one of which we probably see here, included "deluge and monitor streams, hose races, rescues from tower tops by ladders and automatic escapes, [and] carrying bodies down tall ladders." A fire brigade officer was always on duty "with big fire bel[l] and steam fire whistle both at his hand." A $6,000 LaFrance hook-and-ladder truck, a 1,200-gallon-per-minute Underwriters pump in the powerhouse, and seven chemical engines were some of the apparatus available to club firemen. *Ref.: Lake Placid Club Handbook.* Lake Placid: 1914.

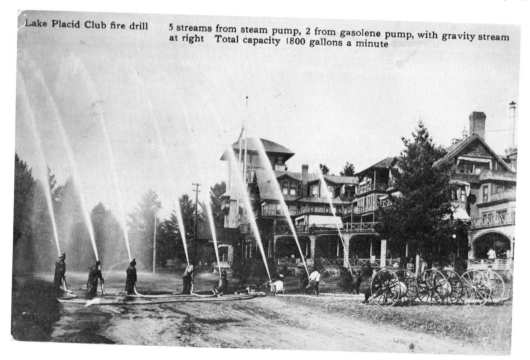

Lake Placid Club fire drill 5 streams from steam pump, 2 from gasolene pump, with gravity stream at right Total capacity 1800 gallons a minute

149. MIDDLETOWN, NEW YORK.

Excelsior's new Seagrave truck carrying 325 feet of ladders went into service on December 18, 1907. Amos R. Doremus was driver with his brother Reuben C. as the assistant. Frank and Charlie, who had pulled the Excelsior's old Seagrave since 1903, responded to alarms with the new Seagrave until 1913 when a three-horse hitch displaced them. The newer Seagrave lasted until 1927.

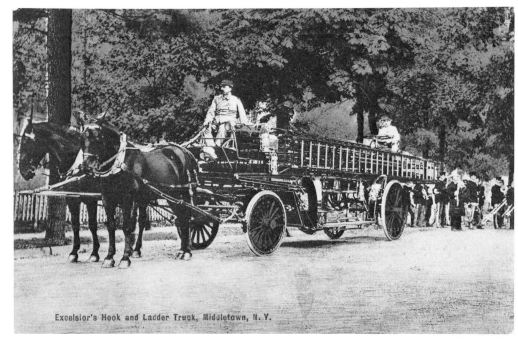

Excelsior's Hook and Ladder Truck, Middletown, N. Y.

The Doremus brothers were paid drivers in an otherwise volunteer fire department, which the city directory in 1913 called the "most efficient and best equipped in the State." President of Excelsior Hook and Ladder Company Number One that year was Frank Harding, a banker. Foreman was Dr. Harvey S. DeWitt, a dentist. *Refs.*: Middletown city directories: 1899, 1903, and 1913. Radzinsky, Charles L. *Brave Men and Bright Machines*. Middletown: 1959.

150. MT. VERNON, NEW YORK. Introduced in 1911, the three-wheel, four-cylinder, 35-horsepower Knox tractor allowed fire departments to convert their apparatus from horse to motor tow. Mt. Vernon Truck Company Number One, posed here outside fire headquarters at 211 South Fourth Avenue, had both electric and acetylene lighting on their Knox. In the early 1910's, the building housed both Truck One under Captain Charles H. Bard and Engine Number Three. In the late 1910's, Truck One apparatus was described as the Knox and a 65-foot Seagrave aerial with water tower connection, fifty feet of 3½-inch hose, and a life net. *Refs.*: McCall, Walter P. *American Fire Engines Since 1900.* Glen Ellyn, IL: 1976. Mt. Vernon city directories: 1909–1913. Sanborn insurance map: 1918.

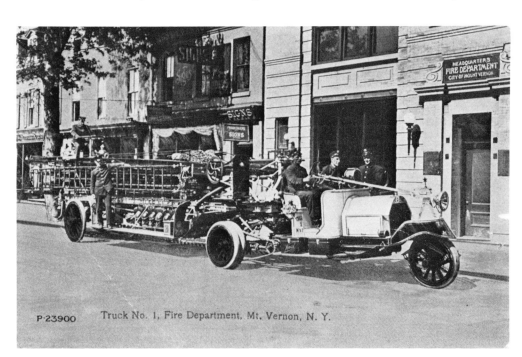

P-23900 Truck No. 1, Fire Department, Mt. Vernon, N. Y.

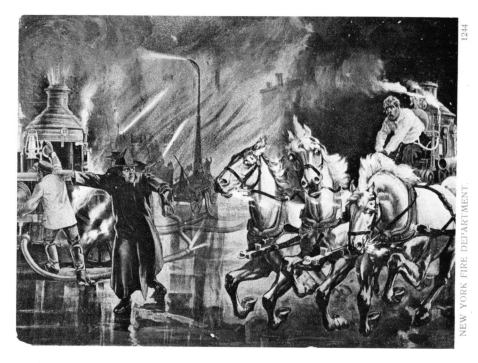

NEW YORK FIRE DEPARTMENT.

151. NEW YORK CITY, NEW YORK.

Here is an imaginary firefighting scene around 1908. The engine on the right is a late arrival on the fire ground, perhaps responding to a second (or even later) alarm. The engine on the left is already hard at work as is the water tower in the background.

152. NEW YORK CITY, NEW YORK. Edward F. Croker became chief of the New York Fire Department in 1900. As nephew of Tammany Hall boss Richard Croker, the chief was dismissed from office by reform mayor Seth Low in 1902. But with another change in government, Croker resumed his office in 1904 and served until 1911 when the

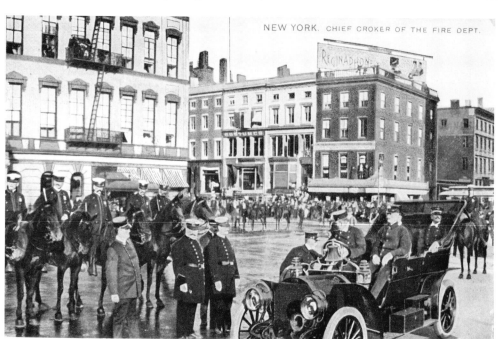

original photograph for this postcard was made. Because of his fearlessness on the fire ground, Croker was popular with his men. In 1906, they numbered 3,562. With 1,500 horses, they operated 150 engines and fifty ladder trucks. *Ref.*: Limpus, Lowell M. *History of the New York Fire Department*. New York: 1940.

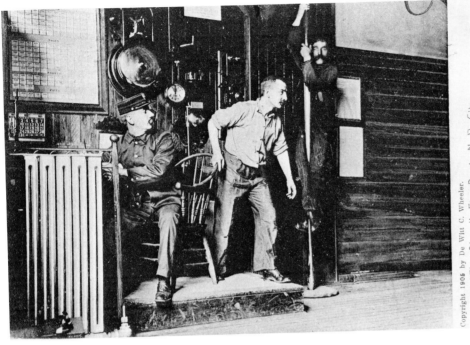

Copyright 1905 by De Witt C. Wheeler. "The Alarm", Fire Dept., N. Y. City.
A 122b *from willie*

153. NEW YORK CITY, NEW YORK. Apparently part of a series (perhaps the same series that includes Card 154), this posed postcard scene shows the station watch (left) observing the actions of the firemen reaching the apparatus floor via the pole from their quarters on the floor above. Although the copyright date is 1905, the calendar above the radiator reads May, 1904.

154. NEW YORK CITY, NEW YORK. A risky maneuver in the best of circumstances, jumping into a life net is demonstrated here with the fireman in the preferred position of arms and legs held away from the body. This leap was from an aerial ladder. A water tower is parked at the right.

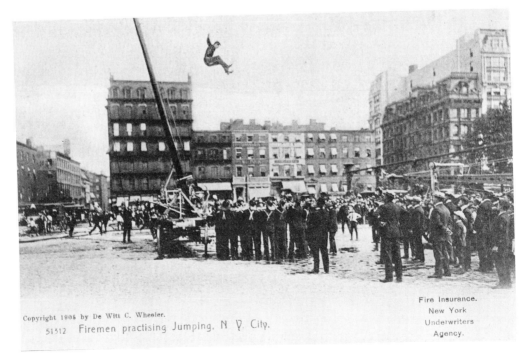

Copyright 1905 by De Witt C. Wheeler.
51312 Firemen practising Jumping. N. Y. City.

Fire Insurance.
New York
Underwriters
Agency.

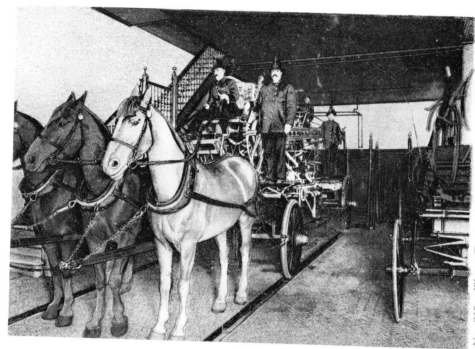

No. 315. Water Tower, New York Fire Department, N. Y.

Copyright 1907 T. M. & N. Co., N. Y.

155. NEW YORK CITY, NEW YORK.

This heavily re-touched postcard shows one of the six Hale water towers acquired by the New York Fire Department in the 1890's and 1900's. Two of them had 55-foot masts, and four had 65-foot towers. The latter group was motorized in the 1910's. Note the track in the station house floor and the swinging harness over the wagon at the right. *Ref.*: Hass, Bill. *History of the American Water Towers*. Sunnyvale, CA: 1988.

156. NEW YORK CITY, NEW YORK. This self-propelled Nott engine assigned to Engine Company 58 in 1911 was rated at 700 gallons-per-minute. Unlike contemporary, front-drive tractors designed to pull extant, previously horse-drawn steamers, this machine combined a steam pump with a gasoline engine powering the rear wheels via roller chains. Its top speed was thirty miles per hour. Built by the W. S. Nott Company of Minneapolis, the engine cost $9,722. The original photo for this postcard probably dates from the early period of the Nott's use. It was the first self-propelled engine in New York City service, although another motor rig—perhaps an aerial—appears in this postcard on the left. *Ref.*: McCall, Walter P. *American Fire Engines Since 1900*. Glen Ellyn, IL: 1976.

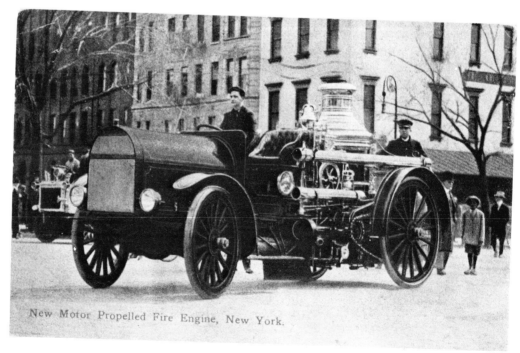

New Motor Propelled Fire Engine, New York.

157. NEW YORK CITY, NEW YORK.

A big year for motorization of New York City fire apparatus was 1911. In addition to the first internal combustion-powered engine (see previous card), this Couple Gear tractor was attached to a Hale water tower that was previously horse-drawn. The gas-electric hybrid had a gasoline engine that drove a generator powering a three-horsepower motor at each wheel. The Couple Gear Freight Wheel Company was in Grand Rapids, Michigan. *Refs.:* Limpus, Lowell M. *History of the New York Fire Department.* New York: 1940. McCall, Walter P. *American Fire Engines Since 1900.* Glen Ellyn, IL: 1976.

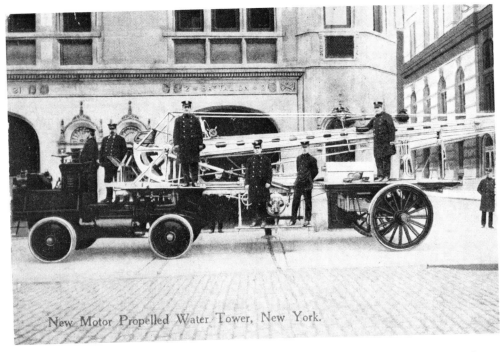

New Motor Propelled Water Tower, New York.

158. NEW YORK CITY, NEW YORK.

The artist incorporated more activity in this postcard than a photographer could hope to capture, especially at a night fire. Here we see (left to right) firemen aiming their playpipe at a fourth floor window, a searchlight wagon powered by a steam engine and generator, ground ladders being used for rescue work, firemen stretching hose from a wagon (extreme right), another stream aimed at the blaze, a life net rescue, a fireman running with an axe, a water tower stream aimed at the burning roof, another ground-based stream, and a steam engine pouring out black smoke.

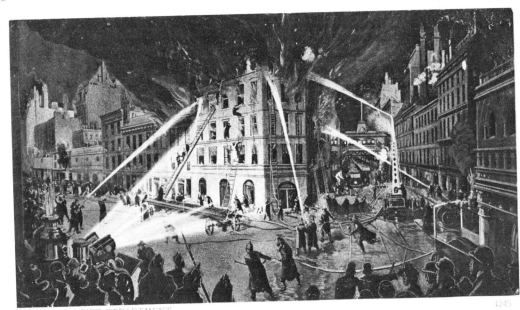

NEW YORK FIRE DEPARTMENT.

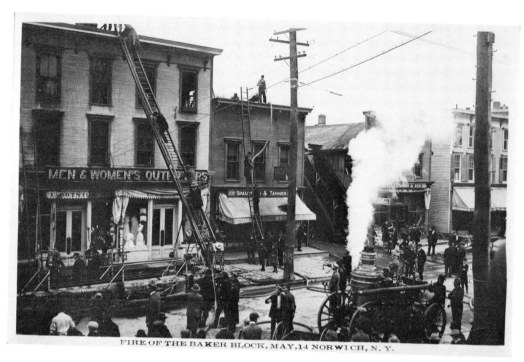

FIRE OF THE BAKER BLOCK, MAY, 14 NORWICH, N. Y.

159. NORWICH, NEW YORK.

The Baker fire of 1912 began when Mrs. L. J. Barber dropped a lamp in a second-story clothes closet. Mrs. Barber, enveloped in flames, suffered fatal burns. A second fatality was a Barber relative, Edward P. Tracy, who died on a stairway. The third casualty, despite a ladder rescue from a third-story window, was Mrs. B. G. Thurston.

Norwich's new chemical engine "stayed the blaze" until the steamer began work. Within an hour and a half, the fire was out. Damage was confined to the building owned by the E. D. Baker estate. Total material loss was about $30,000, mostly to the ground floor of the Louis Botnick Department Store.

On the left of this card is the volunteer fire department's Hayes aerial, the horses for which were supplied by a livery stable near the fire station. *Refs.*: Chenango County Firemen's Association Fiftieth Anniversary Convention Program, 1972. *The Chenango Telegraph.* May 17, 1912. Sanborn insurance map: 1910.

160. MINOT, NORTH DAKOTA.

First settled in 1886, the Ward County seat became a city with a commission form of government in 1909. The next year, the Minot city directory described the "purely" volunteer fire department as "well equipped"; firemen display some of that equipment in this postcard—hose wagon, turnout gear, play pipes, and pet dog. Volunteer or not, Chief Ernest W. Thompson roomed at City Hall. *Ref.*: Minot city directory: 1910.

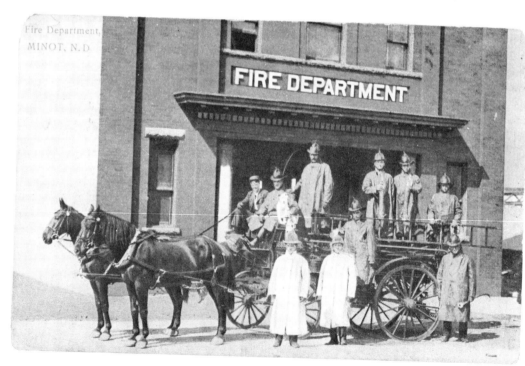

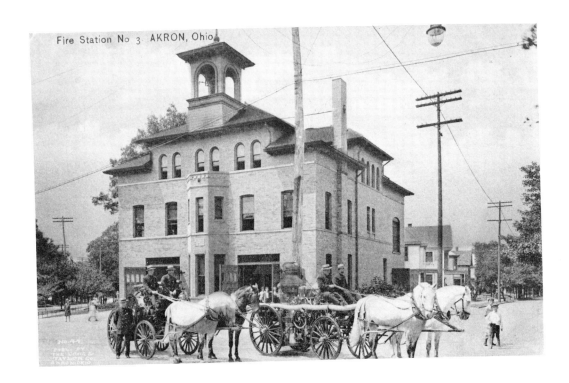

Fire Station No 3 AKRON, Ohio.

161. AKRON, OHIO. Steam fire engines rolled over Akron's streets beginning in 1866. Perhaps this is the Ahrens purchased in 1886 and reboilered in 1903. The accompanying vehicle is a hose reel rather than the more common hose wagon. The leaves on the trees and the straw hats on the firemen indicate that it was summer at the corner of South Maple and Crosby when the photo for this postcard was taken. *Refs.*: Akron city directory: 1918. American Fire Engine Company. *Illustrated Catalogue of the American Fire Engine Company.* Seneca Falls, NY: 1894. Hass, Ed. *The Dean of Steam Fire Engine Builders.* Sunnyvale, CA: 1986. Walker, Harold S. and Edward R. Tufts. *List of Silsby Steam Fire Engines 1858–1900.* Unpublished: 1986.

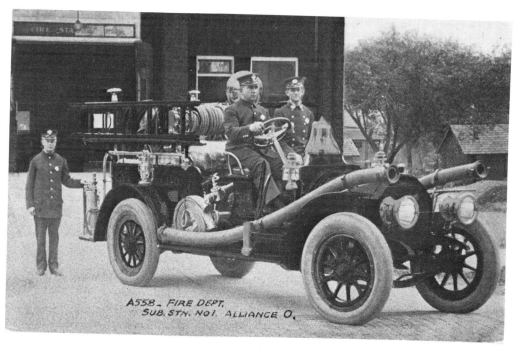

A558 - FIRE DEPT.
SUB. STN. NO.1. ALLIANCE O,

162.-163. ALLIANCE, OHIO. The original photos for these postcards were probably taken about 1910, soon after the delivery of Alliance's new Webb pumper. In Card 162, the chemical tank and its hose are plainly visible. Less obvious are the piston pump and its pressure dome (the latter is behind the driver's head). In Card 163, the efficiency of the pump is plain to see with two strong streams being discharged. The suction hose, carried on the right front fender in Card 162, is pulling water into the engine from the pond in Card 163. Akron, Springfield, and Youngstown were other Ohio cities operating Webb Motor Fire Apparatus Company engines in the early 1910's. *Ref.*: McCall, Walter P. *American Fire Engines Since 1900.* Glen Ellyn, IL: 1976.

163.

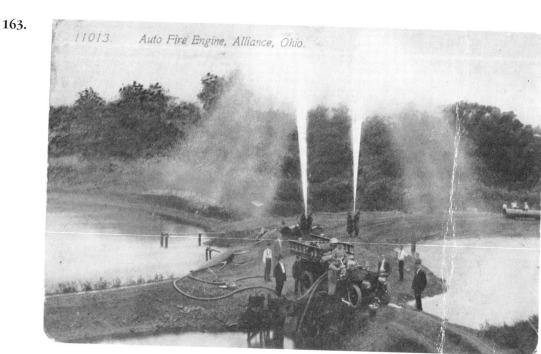

11013. Auto Fire Engine, Alliance, Ohio.

164. CANTON, OHIO.

In the 1910's, this Central Station was one of eight fire houses serving the Canton Fire Department. Chief was Robert O. Mesnar. His assistant was Frank X. Schario, who was also captain at Station One in 1913. By 1921, the horse-drawn engine and ladder truck had been replaced by motor vehicles. The motor apparatus

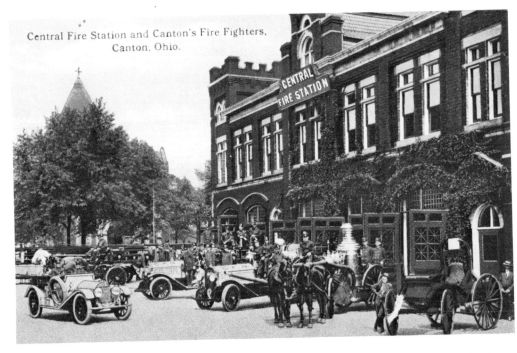

Central Fire Station and Canton's Fire Fighters, Canton, Ohio.

seen here are Seagraves, manufactured in Columbus. One wonders about the wagon at the right; perhaps with its crepe paper or flower bell it was prepared for a parade. *Refs.*: Canton Chamber of Commerce. *Canton: A City of Homes, Diversified Industries and Real Opportunities.* Canton: 1921. Canton city directories: 1913 and 1921.

165. TULSA, OKLAHOMA. In 1911, about the time the photo for this postcard was taken, Tulsa had a paid fire department that operated an engine, a hook-and-ladder truck, and two hose wagons. It is one of the wagons that we see here. Note the fender over the rear wheel. Apparatus was housed in three separate stations. *Ref.*: Tulsa city directory: 1911.

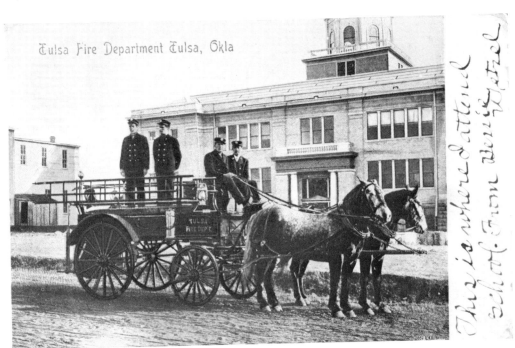

Tulsa Fire Department Tulsa, Okla

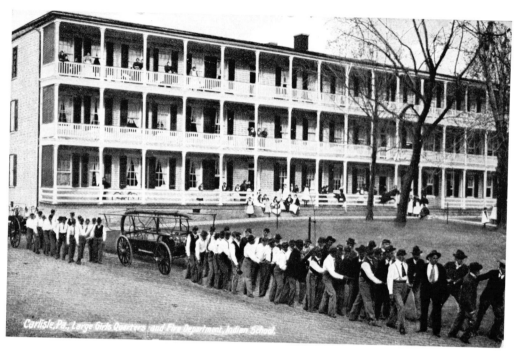

166. CARLISLE, PENNSYLVANIA. From 1879 to 1918, the United States Army barracks at Carlisle housed the Carlisle Indian Industrial School. The students formed their own fire department. In this postcard, they are posing with a hose reel (far left) and a squirrel tail, crane neck, side stroke, and hand engine. Certainly, there was no shortage of manpower to operate the brakes (handles) of the engine. *Ref.*: Flower, Milton E. *This is Carlisle.* Harrisburg, PA: c. 1944.

167. CHESTER, PENNSYLVANIA. Here is a postcard that conveys the excitement of a horse-drawn steam engine underway—the driver concentrating on his work, the engineer enveloped in a mixture of coal smoke and road dust at the rear, and the horses galloping at the front. Apparently, this engine was rolling in a trolley track. Chester acquired a first-size Silsby engine, "Little Frank," in 1894. *Ref.*: Walker, Harold S. and Edward R. Tufts. *List of Silsby Steam Fire Engines 1858–1900.* Unpublished: 1975.

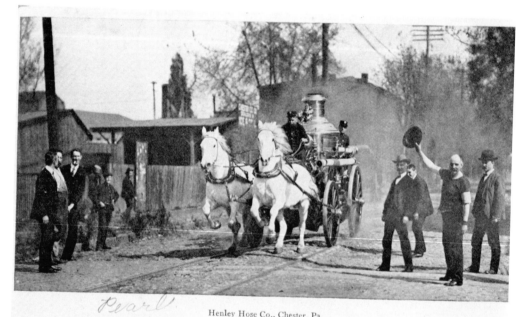

Henley Hose Co., Chester, Pa.

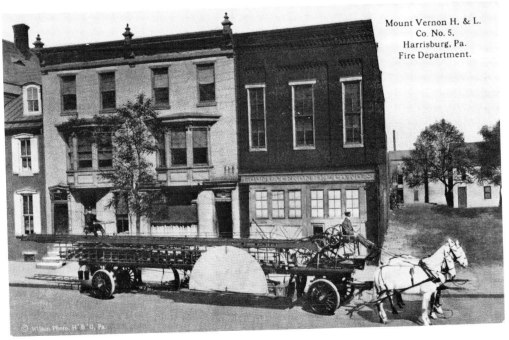

168. HARRISBURG, PENNSYLVANIA. Mt. Vernon's impressive aerial rolled on rubber-shod wheels behind a three-horse team. The vehicle's extreme length required the services of a tillerman to steer the rear wheels. Ground ladders supplemented the aerial ladder attached to the truck. The life net, generally the responsibility of ladder companies, has a prominent position behind the right front wheel.

169. HUMMELSTOWN, PENNSYLVANIA. Speedy to the fire and quick acting on the fire ground—those were the attributes of the chemical engine. On this rig, the main tank was supplemented by the extinguisher on the rear step. The ladder gave access to fires or rescues above ground level. Of course, once the tank-held liquid gave out, the Hummelstown men had to turn to other apparatus.

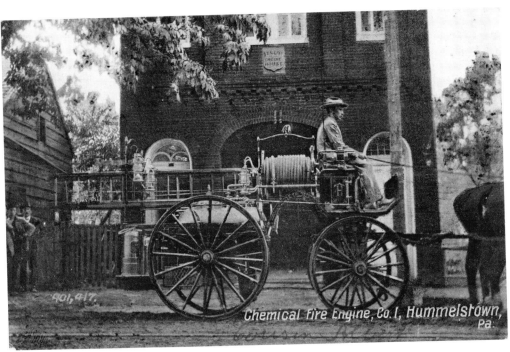

The Wilkinson Postcards

170.–177. PROVIDENCE, RHODE ISLAND. In 1909 or 1910, Robert Wilkinson published a group of postcards depicting the apparatus and station houses of the Providence Fire Department. Wilkinson, who had served as manager of the Bosselman and Company postcard firm in Providence for several years, provided his contemporaries and posterity with a splendid documentation of the fire department at the end of 1907, 1908, or early 1909. Not only did he print nicely colored images, but on the reverse of the cards, he provided extensive data on the apparatus and the companies that operated them.

These Providence cards are a sample from the Wilkinson series. While the author of this present postcard album worked in general only with views on the fronts of the cards, he was able to inspect the reverse side of the Providence cards. Consequently, some of the information published by Wilkinson has been included here.

In 1908, Providence operated fourteen engine companies, eight hose companies, ten ladder companies, and a protectives company. *Refs.*: Providence city directories: 1907–1910.

170. PROVIDENCE, RHODE ISLAND. Hook and Ladder Number One placed this first-size Seagrave aerial in service on April 10, 1905. The ladder extended 85 feet from its anchor at the front of the truck. The rig, rolling on rubber tires, weighed 11,760 pounds. The crew, including both a driver and tillerman, was twelve men. Joseph W. Carpenter was captain when the original photo for this postcard was taken. *Refs.*: Providence city directories: 1907–1909. Reverse of card.

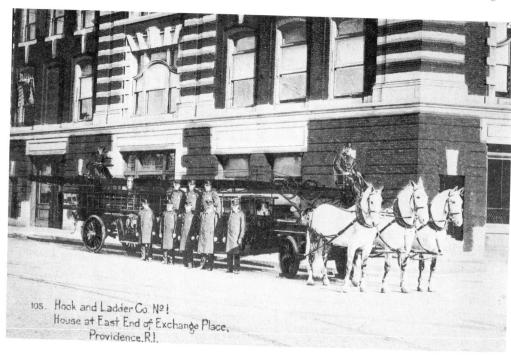

105. Hook and Ladder Co. No 1
House at East End of Exchange Place,
Providence. R.I.

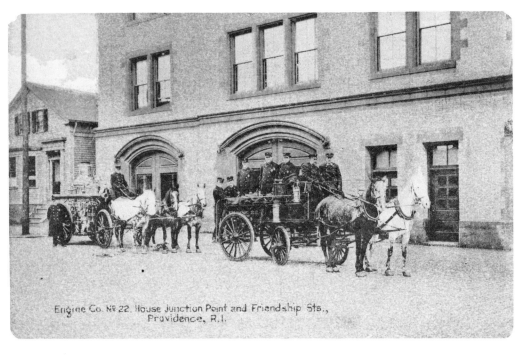

Engine Co. №22. House Junction Point and Friendship Sts.,
Providence, R.I.

171. PROVIDENCE, RHODE ISLAND.

This first-size Metropolitan-style engine (serial number 3025) was assembled by William Woehle at the American-LaFrance shops in Seneca Falls, New York. It was one of two identical machines ordered by Providence in 1904. Nickel-plated and painted "Road Cart Red Glazed with Carmine," the engine was shipped by rail to Stillman White Engine Number 12 on April 12, 1905. It served Number Twelve from May 1, 1905, to November 5, 1907, when it went to the newly organized Engine 22.

There the engine joined the new combination hose- and-chemical wagon that carried a 35-gallon tank. The crew consisted of Captain Abner G. Allen, a lieutenant, five hosemen, one "engine-man," one assistant engine-man, one "hose-driver," and one "engine driver." *Refs.*: American-LaFrance shop specification booklet. Providence city directories: 1908 and 1909. Reverse of card.

172. PROVIDENCE, RHODE ISLAND. This second-size Hayes aerial went into service on January 1, 1890. Then on December 13, a falling wall at the J. B. Barnaby fire damaged the truck, putting it out of service until February 12, 1891.

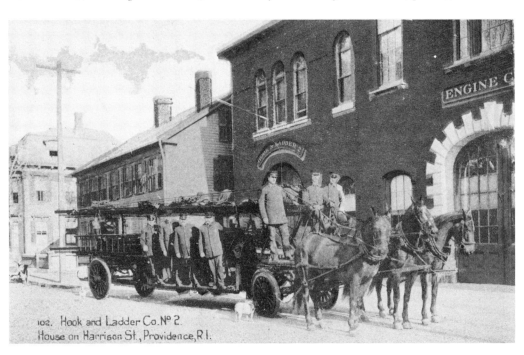

102. Hook and Ladder Co. №2.
House on Harrison St., Providence, R.I.

As seen here about 1908, the Hayes ran on rubber tires behind three horses. The longest ladder was the aerial at 65 feet. The truck weighed 7,000 pounds.

The squad consisted of Captain Thomas R. Gorton, a lieutenant, a driver, and six laddermen. *Refs.*: Providence city directories: 1907–1909. Reverse of card.

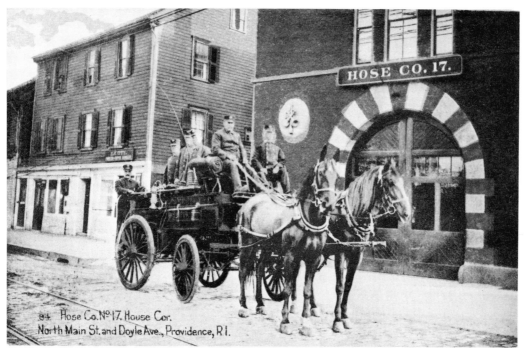

173. PROVIDENCE, RHODE ISLAND. Built as a hose wagon in 1891, this vehicle received a chemical tank in 1899. As seen here around 1908, the wagon ran on roller bearings. Equipped with 800 feet of 2½-inch hose as well as 200 feet of ¾-inch hose for the 21-gallon chemical tank, the wagon weighed 4,522 pounds. Hose Company 17 manpower consisted of Captain William H. Garvin, a lieutenant, a driver, and six hosemen. *Refs.*: Providence city directories: 1907–1909. Reverse of card.

174. PROVIDENCE, RHODE ISLAND. Wagon Number One, built in 1902 and weighing 4,000 pounds, carried 26 tarpaulins. Wagon Number Two, carrying 21 tarps and weighing 3,200 pounds, was placed in service in 1891. The Protectives, organized in 1875, consisted in the late 1900's, of Captain Charles H. Swan, a lieutenant, two drivers, and seven covermen. The last were responsible for covering or removing salvageable property at the fire scene. *Refs.*: Providence city directories: 1907–1910. Reverse of card.

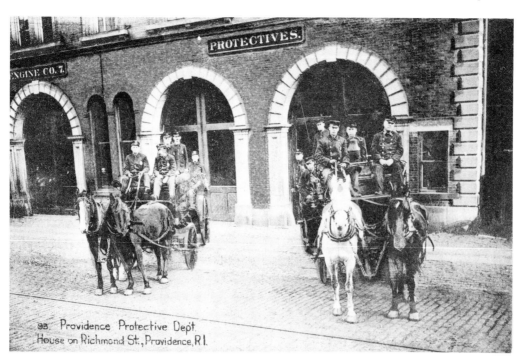

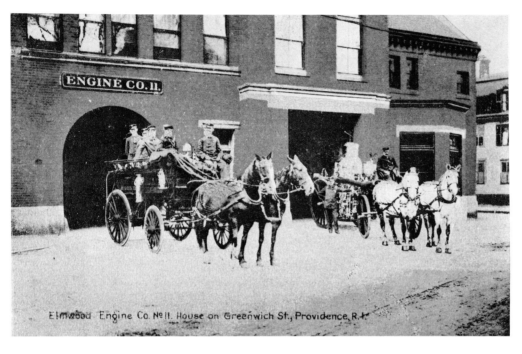

Elmwood Engine Co. Nº II. House on Greenwich St., Providence, R.I.

175. PROVIDENCE, RHODE ISLAND.
Captain Walter A. Vaughan, a lieutenant, two drivers, an engine-man, an assistant, and five hosemen were posted at Engine 11. Their equipment included the combination wagon built as a hose carrier in 1895 and equipped with a chemical tank in 1904, as well as the second-size LaFrance piston pumper built in 1890. The latter had been reassigned to Engine 11 in 1906 shortly before the picture for this post-card was taken. The company operated with 800 feet of 2½-inch hose as well as 200 feet of ¾-inch hose for the 22-gallon chemical tank. *Refs.*: Providence city directories: 1907–1909. Reverse of card.

176. PROVIDENCE, RHODE ISLAND. This card demonstrates that not all Providence trucks were aerials. This trussed-type Seagrave went into service on April 3, 1900. Its longest ladder was a 60-foot extension type, and its weight was 4,850 pounds when fully equipped. The crew consisted of a captain, lieutenant, driver, and five laddermen. *Ref.*: Reverse of card.

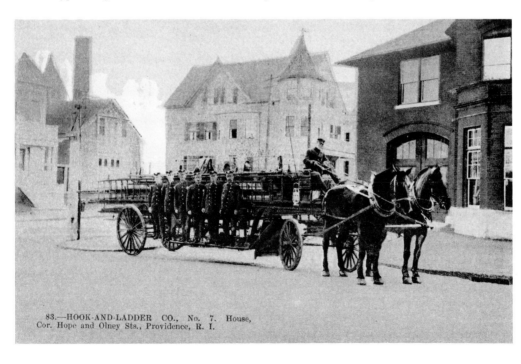

83.—HOOK-AND-LADDER CO., No. 7. House,
Cor. Hope and Olney Sts., Providence, R. I.

**177.
PROVIDENCE,
RHODE ISLAND.**
Atlantic's first-size American steamer, built in 1896, served Engine Four until 1899. Its engine had nine-inch by eight-inch steam cylinders over 5½-inch by eight-inch pump cylinders. Running on rubber tires, the vehicle weighed 8,940 pounds when ready for operation.

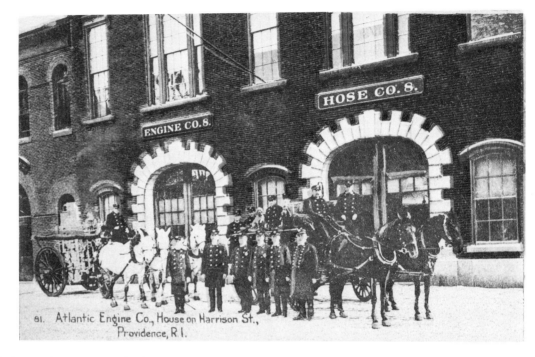

81. Atlantic Engine Co., House on Harrison St., Providence, R.I.

The companion combination hose-and-chemical wagon was built as a straight hose carrier in 1892 and converted in 1899. It hauled 800 feet of 2½-inch hose and 200 feet of ¾-inch hose for the 30-gallon tank. It, too, ran on rubber tires but weighed 4,250 pounds.

Atlantic's captain, probably standing on the right in the postcard, was Frank E. Taber. His crew consisted of a lieutenant, two drivers, an engineer, an assistant, and five hosemen. *Refs.*: Providence city directories: 1907–1909. Reverse of card.

178. PROVIDENCE, RHODE ISLAND. This card is not from the Wilkinson series; it shows, in retouched format, Engine 8 rounding a corner. Spectators' fascination with steam fire engines is reflected in their attentiveness. It's an enthusiasm shared by the attention of those looking at these views almost a century after their publication.

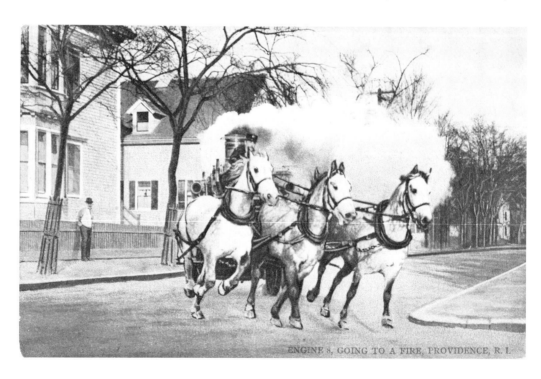

ENGINE 8, GOING TO A FIRE, PROVIDENCE, R. I.

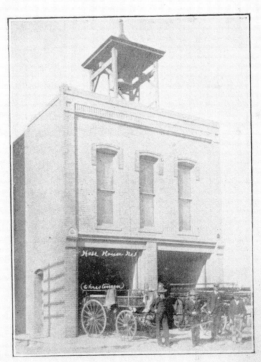

PIERRE HOSE HOUSE NUMBER 1

179. PIERRE, SOUTH DAKOTA. Laid out in 1880 and incorporated in 1883, Pierre became South Dakota's capital in 1904. About that time, the photo for this postcard was taken of Hose Number One and the ladder truck. Note the shadow of the cross arms of a telephone pole on the side of the fire house. *Refs.*: Federal Writers' Project. *A South Dakota Guide.* Pierre: 1938. Robinson, Doane. *A Brief History of South Dakota.* New York: 1905.

180. CHATTANOOGA, TENNESSEE. Chattanooga's first motor apparatus, this Seagrave piston pumper and chemical engine, arrived in August, 1913. As Engine Six, the Seagrave responded to all alarms. Note the large pneumatic tires and the roof ladder.

In the early 1910's, the city's equipment roster also included five steam engines. *Refs.*: Chattanooga city directory: 1910. *History of the Chattanooga Fire Department, 1871–1975.* Chattanooga: 1975.

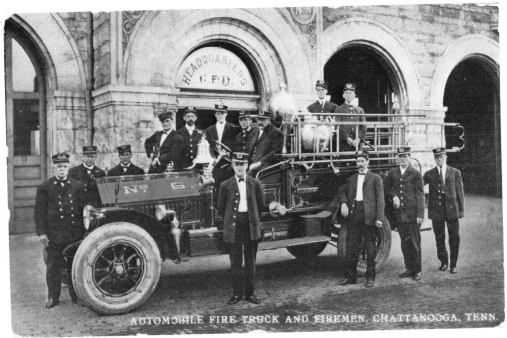

AUTOMOBILE FIRE TRUCK AND FIREMEN, CHATTANOOGA, TENN.

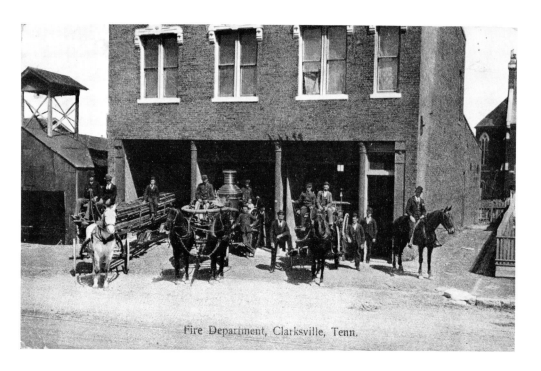

Fire Department, Clarksville, Tenn.

181. CLARKSVILLE, TENNESSEE.

The Clarksville firemen made do with as few horses as possible. Most departments would have hitched two equine helpers to the ladder truck, and many would have put two horses in front of the hose wagon. Two horses *were* needed for the steam engine, a heavier vehicle than the others. Clarksville bought a Silsby engine, possibly this machine, in 1872.

Might the man on horseback be the fire chief? *Ref.*: Walker, Harold S. and Edward R. Tufts. *List of Silsby Steam Fire Engines 1858–1900.* Unpublished: 1975.

182. DALLAS, TEXAS. This model station stood on the northwest corner of Elm and Houston Streets. Quartered here in 1908 were Engine Number Five and Hook and Ladder Number One, both under Captain Ernest O. Jones.

Equipment for the entire fire department under Chief Hugh F. Magee included eight engines, two chemicals, two trucks, three hose wagons (or reels), and "plugs on every corner."

This site eventually became part of Deeley Plaza. *Refs.*: Dallas city directories: 1903, 1908, and 1911. Deeley, Ted. *Diaper Days of Dallas.* Nashville: 1966.

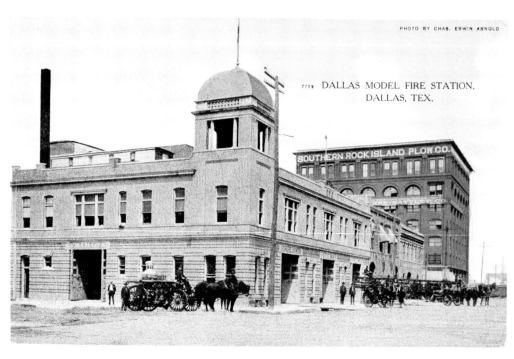

PHOTO BY CHAS. ERWIN ARNOLD

7719 DALLAS MODEL FIRE STATION, DALLAS, TEX.

SOUTHERN ROCK ISLAND PLOW CO.

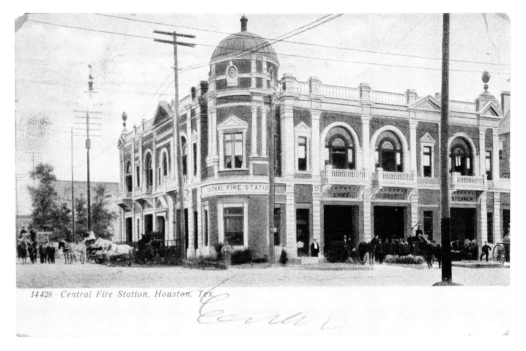

14428 - Central Fire Station, Houston, Tex.

183. HOUSTON, TEXAS.

The Houston Fire Department moved from volunteer to partially paid status in 1893, and all of the firemen were paid in 1895. In 1914, the department responded to 771 alarms from ten stations. This Central Fire Station at 519 San Jacinto housed Number One Service Truck, Number One Hose Wagon, and Number One Water Tower and Aerial Truck. The building was replaced in 1925, three years after the last Houston fire horse was retired. *Refs.*: Beard, Norman H., ed. *The City Book of Houston.* Houston: 1925. Buchanan, James E. *Houston: A Chronological and Documentary History, 1519–1970.* Dobbs Ferry, NY: 1975. Houston city directories, 1913 and 1915. Young, Samuel O. *Thumbnail History of the City of Houston, Texas.* Houston: 1912.

184. McKINNEY, TEXAS. As with many small town city halls, the fire department's accommodation dominated the facade of McKinney's civic building. This structure was notable for its prairie-school style architecture. Note also the fire bell on the roof as well as the swinging harness and the horse in his stable inside the open door. McKinney bought two fourth-size American steam engines in 1895. *Ref.*: Hass, Ed. *The Dean of Steam Fire Engine Builders.* Sunnyvale, CA: 1986.

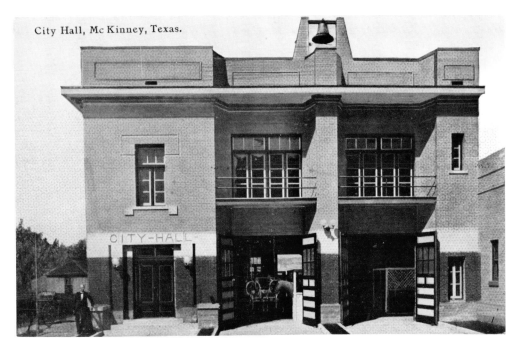

City Hall, McKinney, Texas.

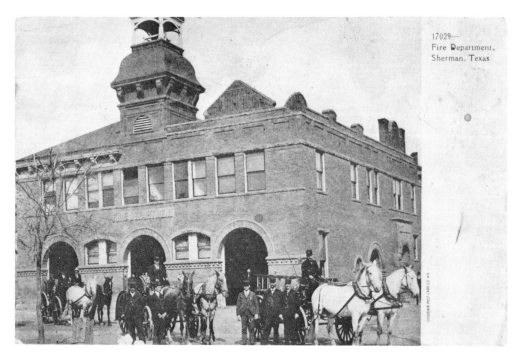

17029—
Fire Department,
Sherman, Texas

**185.–186.
SHERMAN, TEXAS.**
These two cards depict the same location, although the appearances of the building, the street, the apparatus, and the firemen are so different that one might think two different places were photographed for the postcards. Still unresolved in the author's mind is the order in which these cards were printed. What appears to be chemical equipment on the wagon at the right of Card 185 would suggest that it is the more recent image.

Sherman received a second-size Silsby engine in 1873, and a new Fox boiler was fitted sometime later. That new boiler appears in Card 184. The horse-drawn hose reel to the engine's right may also appear in Card 185 as one of the two vehicles on the left. *Ref.:* Walker, Harold S. and Edward R. Tufts. *List of Silsby Steam Fire Engines 1858–1900.* Unpublished: 1975.

186.

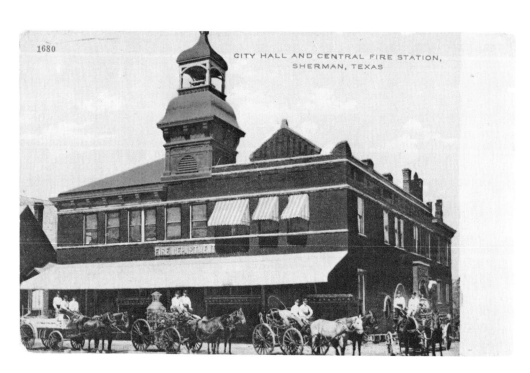

1680 CITY HALL AND CENTRAL FIRE STATION,
 SHERMAN, TEXAS

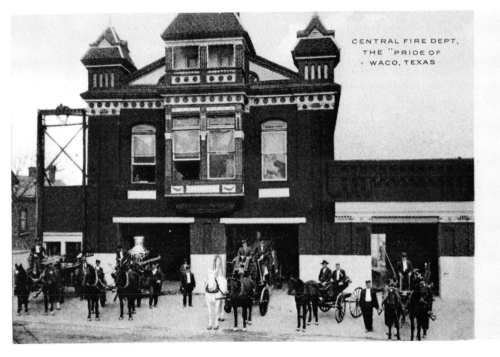

187. WACO, TEXAS.
The Waco Fire Department, organized in 1873, operated Silsby steam engines in its first decade. The department became a paid agency in 1917, a few years after this postcard was printed. This was the Central Station on Washington Street. From left to right we see the hose wagon for the next vehicle, Waco Fire Engine Number One; Rescue Hook and Ladder's truck; the chief's buggy; and Chemical Engine Number One. *Ref.*: Walker, Harold S. and Edward R. Tufts. *List of Silsby Steam Fire Engines 1858–1900*. Unpublished: 1975. A Waco city directory: 1919

188. BARRE, VERMONT. At the end of the nineteenth century, the Barre Fire Department was a volunteer agency with an engine, a hook-and-ladder, and three hose companies. In the twentieth century, paid personnel were added to the department, which included the chief, three assistants, drivers, and pipemen. In addition, in 1912, there were

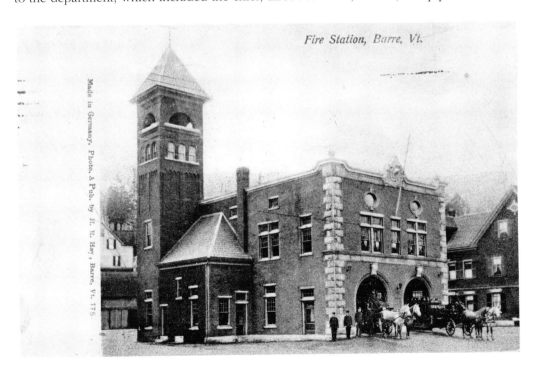

21 callmen with "registration . . . once every month."

Headquarters were at 8–10 South Main Street. Captain of Chemical and Hose Company Number One was Frank G. Rogers, an expressman. Captain of Hook and Ladder Company Number One was Earl C. Cutler, who operated a livery and sales stable. *Refs.*: Barre city directories: 1899, 1908, and 1912.

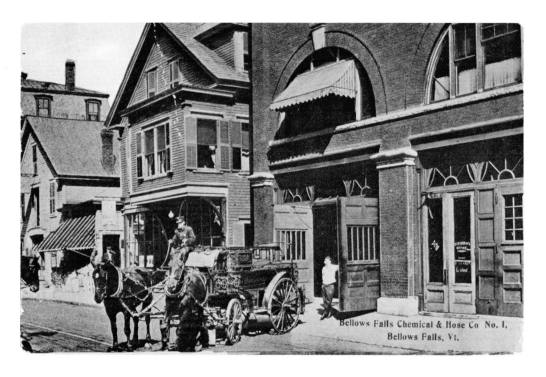

189. BELLOWS FALLS, VERMONT.
In 1899 (probably a few years before the photo for this postcard was taken), Elmer Underhill was foreman of Chemical Company Number One working with a three-man crew. The remaining Bellows Falls fire department consisted of a steamer company, a hook-and-ladder company, and three hose companies. The alarm system was thirteen boxes, four miles of wire, a tower striker in the Methodist Church, a steam whistle in the International Paper Company's number one boiler house, and an automatic register in the hose house. The 65 hydrants had water pressures ranging from 90 to 140 pounds. *Ref.*: Bellows Falls city directory: 1899.

190. BRATTLEBORO, VERMONT. In the early 1870's, three hand engines, including a $4,000 Boston-built Hunneman, provided fire protection for Brattleboro. At the same time, the Jacob Estey organ factory had a steam engine in service; it is probably standing under a chimney on the left of this postcard. This allowed the fire to be lit and hot water to circulate in the boiler before the engine left the fire station. In 1876, the municipality purchased two fifth-size Clapp and Jones engines, which appear at the center and right in this card. *Refs.*: Brattleboro city directory: 1905–1906. Burnham, Henry. *Brattleboro.* Brattleboro: 1880. Walker, Harold S. *Partial List of Clapp and Jones Steam Fire Engines.* Unpublished: 1974.

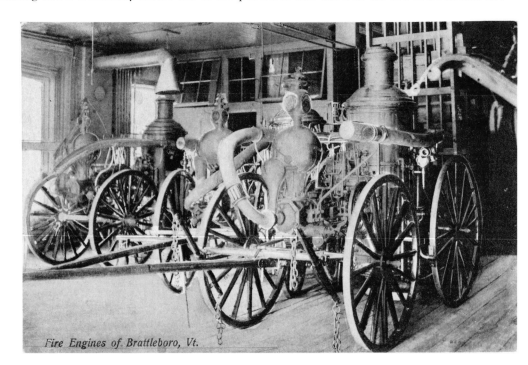

Fire Engines of Brattleboro, Vt.

191. ST. JOHNSBURY, VERMONT.

In January, 1912, the St. Johnsbury village trustees were empowered to spend no more than $7,500 for a "combination automatic fire-truck carrying chemicals." The 70-horsepower American-LaFrance model 14-4 that they purchased had two

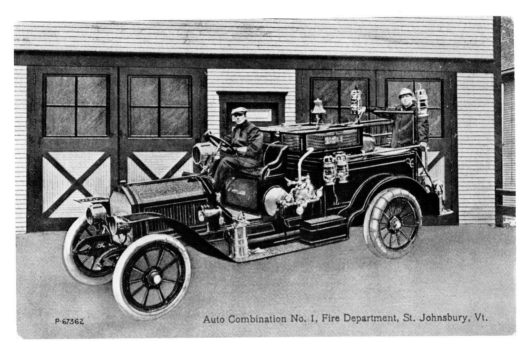

Auto Combination No. 1, Fire Department, St. Johnsbury, Vt.

35-gallon chemical tanks, 400 feet of chemical hose, extension roof ladders, and 1,000 feet of standard hose.

"Under the hand of demonstrator Ruggles of Elmira, its dangerous racket, bright red dress and swift agile actions made a sensation on the streets. It took 25 men across the plain at 47 miles per hour. . . ." *Refs.*: American-LaFrance Fire Engine Company, Ind. *Sales List to May 31, 1927.* Elmira: 1927. Fairbanks, Edward T. *The Town of St. Johnsbury, Vermont.* St. Johnsbury: 1914.

192. NORFOLK, VIRGINIA. In 1896, the Norfolk Fire Department had 51 men, "all receiving a regular salary." Thirteen horses assisted in moving five steam engines, two hook-and-ladder trucks, five hose carriages, and a chemical engine. In this scene, probably from the early twentieth century, we see the chief's buggy, a ladder truck, a hose wagon, and an engine. *Ref.*: Norfolk city directory: 1896.

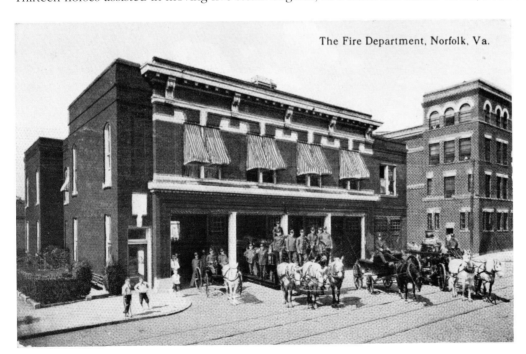

The Fire Department, Norfolk, Va.

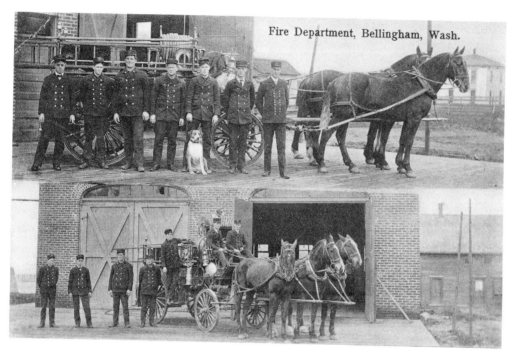

Fire Department, Bellingham, Wash.

193. BELLINGHAM, WASHINGTON.
Here are two views taken of the same subject on the same day. In the first photo, the firemen with their officer (right) and mascot (front, center) stand in front of their combination chemical-and-hose wagon. In the second scene, the driver and officer have taken places on the seat with the dog observing from atop the chemical hose reel. Note the three-horse hitch and large-diameter chemical tank.

194. CENTRALIA, WASHINGTON. A fine combination chemical-engine-and-hose wagon appears to have been the pride of Centralia. The troika of powerful horses added to the rig's fine appearance. Fire extinguishers and ground ladders gave the wagon added utility. Note the concrete apron adjacent to the unpaved street.

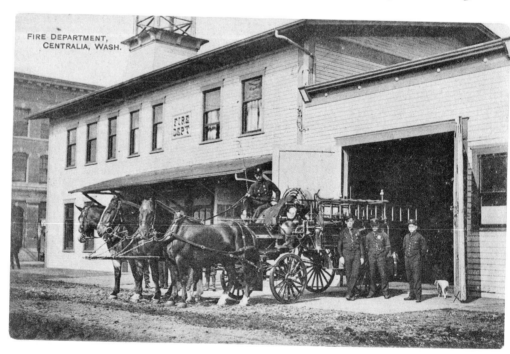

FIRE DEPARTMENT, CENTRALIA, WASH.

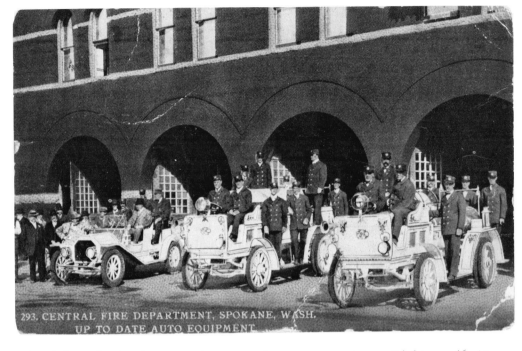

195. SPOKANE, WASHINGTON.

In 1913, the Spokane Fire Department had 129 men and 45 horses in twelve stables. Station Four in the City Hall Annex was under the command of Captain William W. Eichelberger. The car on the left, however, probably served Chief Albert L. Weeks. Apparently, the Seagrave rigs were a hose car (center) and a chemical engine (right). Three years later, the breakdown for the department's personnel was seven engineers, 24 drivers, 46 pipemen, 24 truckmen, three telephone operators, one linemen, six stokers, one secretary, one electrician, and one auto mechanic—in addition to the officers. *Refs.*: Spokane city directories: 1913 and 1916.

196. APPLETON, WISCONSIN. Quick-hitch harness for three horse-drawn vehicles hung from the ceiling of Station One. At the sound of an alarm, the horses would be led (or moved on their own) to stand under the harness, which would be lowered by the white ropes and buckled rapidly. Given the absence of steam engines, we assume Appleton relied upon water-main pressure to fill the hoses of the wagons seen here.

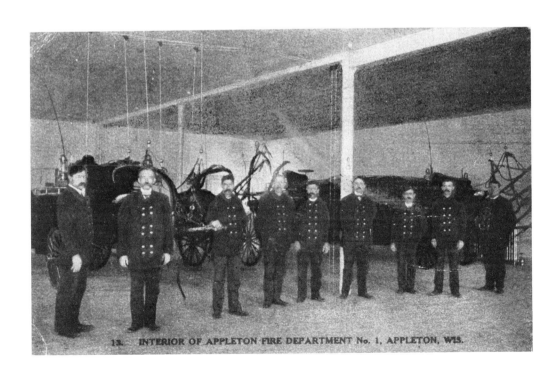

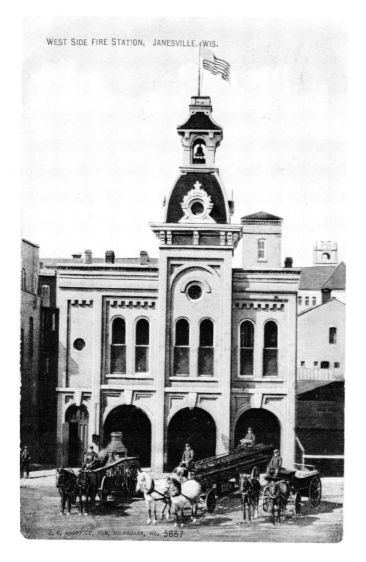

WEST SIDE FIRE STATION, JANESVILLE, WIS.

S. C. KROPP CO. PUB. MILWAUKEE, NO. 5667

197.–198. JANESVILLE, WISCONSIN. Two views of the same location taken a few years apart document the beginning of motorization in Janesville. If the postcard fad had endured another decade, we might well have had a third card showing another Seagrave engine and a tractor-drawn ladder truck instead of the horse-drawn apparatus still operating in the early 1910's. Note the replacement pedestrian door in Card 198—an architectural affront to the West Side Station.

198.

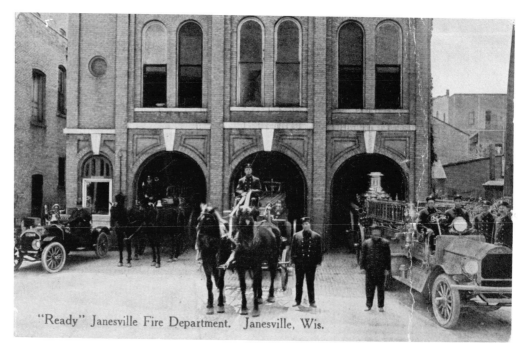

"Ready" Janesville Fire Department. Janesville, Wis.

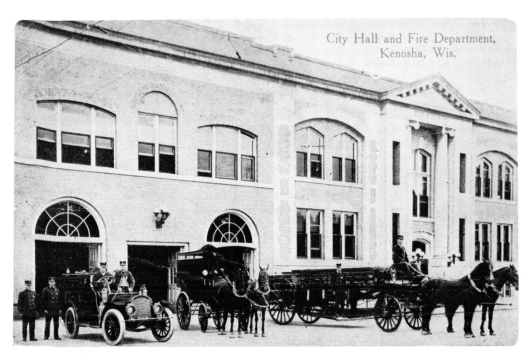

City Hall and Fire Department, Kenosha, Wis.

199. KENOSHA, WISCONSIN.

Rambler motor vehicles were manufactured in a Kenosha factory from 1902 to 1913. The hose wagon on the left appears to be about a 1911 model. We wonder about the covered wagon at the center of the photo-graph — covered fire vehicles of any type were unusual in the early twenti-eth century. The fire station and City Hall were on 56th Street in Kenosha. *Refs.*: Kenosha city directory: 1933. Kimes, Beverly Rae and Henry Austin Clark, Jr. *Standard Catalog of American Cars 1805–1942.* Iola, WI: 1985.

200. MILWAUKEE, WISCONSIN. In 1907, the Milwaukee Fire Department had 29 engines, including eight Metro-politan-type Americans, four other Americans, and twelve Ahrens. Most of these were second-, first-, or extra first-sizes. Most were also products of the late 1880's, 1890's and 1900's, although a few of the Ahrens were older—one of them dated from 1879.

Other apparatus included twelve hook-and-ladder trucks, eight chemical rigs, one water tower, and one fireboat. A privately financed insurance patrol augmented the publicly funded department. *Refs.*: Milwaukee city directory: 1907. Nailen, R. L. *Beertown Blazes.* Milwaukee: 1971.

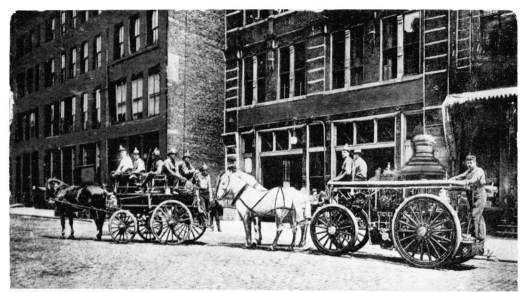

HOSE CART AND ENGINE.

E. C. KROPP, PUBL. MILWAUKEE, NO. 2515

DOCUMENTING THE POSTCARD CAPTIONS

To a degree, the author's knowledge provided the basis for the captions accompanying the postcard images in this book. He has worked with firefighting artifacts for several years in his capacity as a museum curator. Consequently, when the reader encounters a caption for which there is no printed reference, s/he can assume that the data is based upon the writer's prior knowledge combined with an inspection of the picture.

It should be noted, however, that scrutiny of the images was tempered by working with photographic copies of the postcard views. And the quality of the original postcard images was often not very good to begin with; many of them were rather coarse, retouched half-tones at the time of publication.

Without a first-class library at hand, it would not have been possible to produce these captions. The writer was fortunate to have the resources of the New York State Library close at hand for continuing reference. Within the library, he made use of a local history collection that is strongest in works on the New England and Middle Atlantic states. This bias meshed with the writer's experience in years past when he concentrated on the history of firefighting in New York. Given that the center of population was closer to the Northeast corner of the United States in the early twentieth century than now, it is not surprising that, on the whole, the postcards of the Northeast are more numerous and perhaps better documented than others in this volume.

Some of the works consulted in the library were city and county histories written at the end of the nineteenth and the beginning of the twentieth centuries. These histories provide sketches or essays on fire department organization and development. The publications of chambers of commerce, which sought to boost communities by praising their fire suppression capacities, are another source of fire department descriptions.

More information was often found in city directories, of which the New York State Library has a fine collection from many places in the United States. Sometimes the directories have only brief mention of the local fire department; but sometimes the information is extensive, describing apparatus and even department salaries.

The Sanborn insurance maps are invaluable aids to documenting fire protection in municipalities. The New York State Library has microfilm copies of these maps for communities in New York.

Other sources of information for the captions in this book were periodicals and monographs on firefighting. Some of these works are contemporary with the images. Other works are recent, historical efforts. In the past few years, for example, dedicated researchers have sought to document the output of major steam fire engine builders; those lists have proven invaluable here.

In 1987, the New York State Library received a gift of the extensive firefighting collection of the late Albany surgeon Thomas S. Walsh, who began accumulating fire-related materials in the early twentieth century. His rare and helpful volumes were consulted in the preparation of this book.

To a limited extent, the writer sought historical repositories and authorities in the communities where the photos were taken. Historical societies, libraries and consultants were able to provide useful and interesting information.

Geoffrey N. Stein